ON THE NATURE OF THINGS

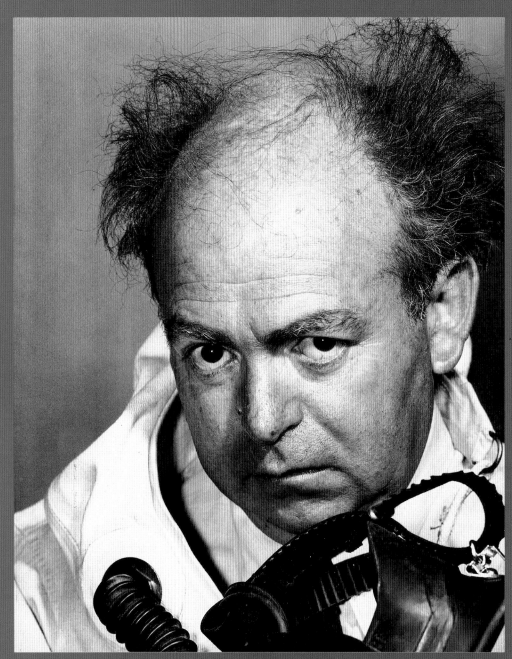

Portrait of Fritz Goro, by Yale Joel, 1958

ON THE NATURE OF THINGS

The Scientific Photography of

FRITZ GORO

APERTURE

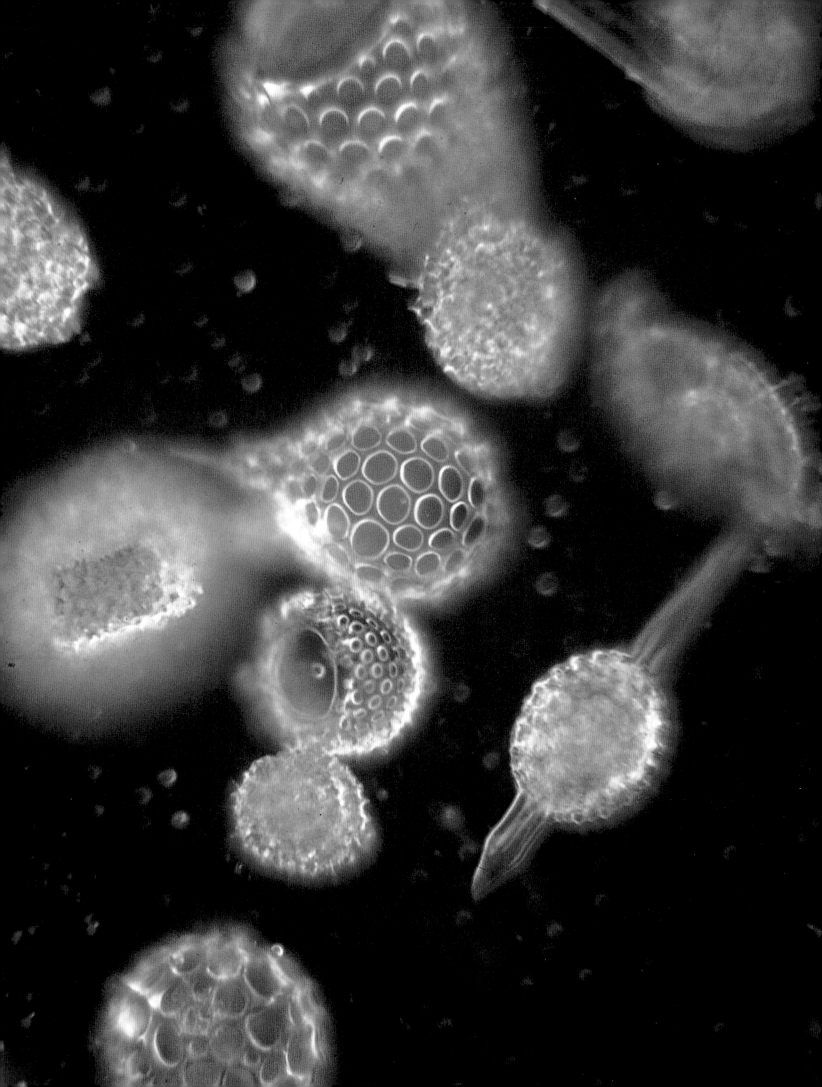

TABLE OF CONTENTS

Marine Microfossils.
Fossils of Radiolaria, single-celled animals, obtained from samples
of ocean sediment. Goro Studio, New York, 1976.

INTRODUCTION

by Stephen Jay Gould

According to an old Chinese legend, a wealthy man commissioned the finest artist of his region to draw him a fish. The artist said that the task would take him a year, but the time passed and no drawing appeared. The rich man complained, and the artist protested that he needed additional time. Several more years passed, and, finally, the rich man became impatient. He visited the artist and said: "I must have the drawing now or I will cancel the contract." The artist took his brush and a piece of paper. He dipped his brush in the ink and, within thirty seconds, drew the most exquisite fish ever made by an artistic hand. The rich man was well satisfied, but intensely puzzled, and he asked: "But if you can do something so beautiful in thirty seconds, why did you make me wait seven years?" The artist said nothing, but led the rich man to a large cabinet. He opened the cabinet, and thousands upon thousands of fish drawings—the years of preparation for the perfect product—fell out.

True professionalism, at the highest levels (called "world class" among sportsmen), demands this kind of perfectionism and this manner of obsessive commitment. The consuming public may appreciate the final product but rarely has any understanding of either the preparatory training involved, or the immediate labor of suboptimal and discarded preliminary attempts. When a one-day meeting runs smoothly and effortlessly, the months-long diligence of a superb organizer goes unnoticed (administrators bear the odd burden of being noticed only when they screw up). The effortless grace of a dancer, the stunning efficiency of a great surgeon, may take but a moment in execution, but can only arise from years of rigorous training. And the "perfect" shot of a photographer—so often seen by the public as a lucky moment—arises from years of devoted training, and often a cabinetful of rejects as numerous as the fish drawings of my initial tale. Much truth resides in Pasteur's old aphorism that "fortune favors the prepared mind."

Such patience to secure the best requires a rare mixture of enlightenment and patronage. (Poverty rarely permits such leisure for preliminaries, and wealth is rarely willing to wait so long.) The *New Yorker*, under the legendary Mr. William Shawn, nurtured and encouraged writers for years—and paid them as well! —until a single superb piece could be produced. *Life* magazine played the same role in the realm of photojournalism. They had both the resources and the commitment to hire and pay the very best, to respect their professionalism, and to know the primary secret of the trade—that one good picture is not only worth the thousand words of Confucius's famous dictum, but may require a thousand preliminary tries as well.

It is strange indeed that the world of scholarship, and high culture in general, does not value the pedagogical photography (and drawing) of images, while it pays endless praise to the texts of literature and the productions of so-called "fine art." Scholars tend to view photos and drawings as illustrative material only, purely supplementary to text, often gathered together as a section in the middle of a book, and therefore divorced from appropriate contexts. Thus the professionalism of a great *New Yorker* writer wins greater acclaim than the equally rare professionalism of a great *Life* photographer.

Although I am only a writer, and cannot function photographically above the complexity of a point-and-shoot Polaroid, I regard this attitude as not only foolish, but also unbiological in the extreme. Humans are primates and primates are quintessentially visual animals. We respond to images as powerfully as to texts. Our major and enduring impressions of many people and events reside not in their words, but in their canonical images—the raising of the flag on Mount Suribachi, Krushchev pounding his shoe on the U.N. podium. This principle holds in science as well as in politics. If I ask: Who was most responsible for forming the concept of dinosaurs held by professionals and the public alike until this generation?—the answer is Charles R. Knight, who produced all the famous murals and reconstructions in American museums, not any anatomist or evolutionary theorist.

Fritz Goro was the most influential photographer that science journalism (and science in general) has ever known—or ever will, for his style of uncompromising veracity in depicting objects of nature will never be called upon again in an age when computer simulations produce "better" icons for many natural occurrences. (I never met Goro, but had the honor of once writing a text to accompany his exquisite photographs of microscopic Radiolaria and their skeletons of silica.) He was able, over the course of a long and rich life, to

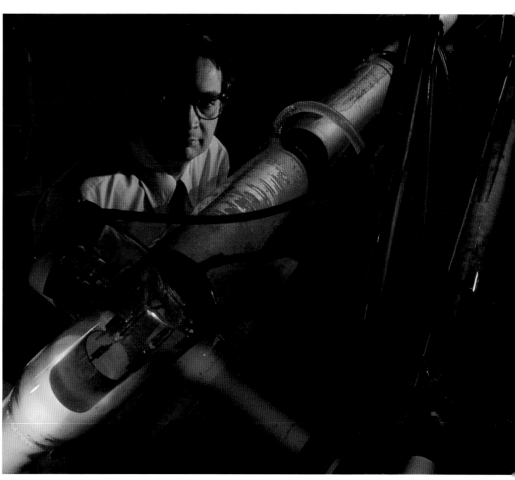

Inventor of the gas laser, Dr. Ali Javan, Professor of Physics at Massachusetts Institute of Technology. Cambridge, Massachusetts, 1971.

produce this unique oeuvre of excellence, thanks to a happy combination of circumstance, background, and temperament: the ungrudging support and understanding of a behemoth known as *Life* magazine (who would pay a year's wages for a superb image or two, if the production took as long); the fortunate temperament of unbounded energy and obsessive drive to perfection; and the intellectual commitments of a great culture—European Jewry—that human evil and madness nearly destroyed, but that will always live through its enduring products and the expansive vigor of its displaced survivors.

Many people falsely equate science photography with pretty pictures of organisms, luckily captured at auspicious moments. But Fritz Goro knew that each icon posed an intellectual puzzle.

Many of his greatest photographs capture highly abstract concepts of physics, and he often struggled for months to find or construct icons that would share the necessary features of accuracy, instruction, and beauty. Each photograph herein is its own intellectual essay, and I was thrilled by the stories of how Goro captured the instantaneous and "invisible" laser beam with smoke, or how he instructed the inventors of holograms in setting up an image that would properly convey their accomplishment. And please do not imagine that photos of organisms are just pretty snapshots (while lightning bolts and DNA molecules may require more thought), for organisms present just as many puzzles in representation. Thus, I thrill just as much to Goro's solutions of letting organisms take their own pictures (autoradiogram of a rat exposed to fallout at Bikini Atoll, photo of "railroad worms" glowing with two colors in their bioluminescence), or of capturing the stunning details of fossil insects amidst the air bubbles and reflections in their enclosing amber.

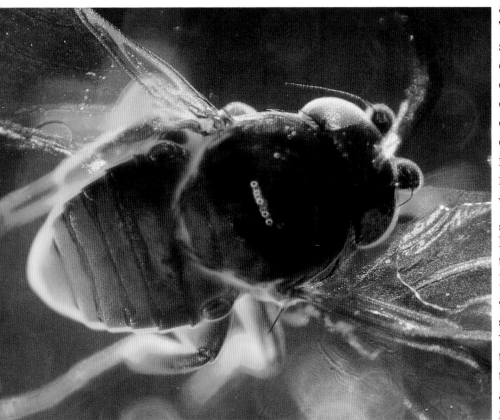

A fly, preserved in amber for millions of years, from the collection at the Museum of Comparative Zoology, Harvard University. Goro Studio, New York, 1982.

We must fight the B-movie image of great science photographers as muscular romantics who nearly lose their life to a charging elephant in darkest Africa. Fritz Goro had his share of adventures and dangers in the field (his ethnographic photos are not included in this volume, but would make a fine study in themselves). But his greatness lay in the world of the mind, and in his unique ability to transfer the most world-shaking of our abstract concepts into icons. Such a task required scientific understanding at a professional level, and Goro's greatest testimony must come from scientists in their trenches who said, over and over again, "he understood everything I did, and he showed me a way to render my results pictorially; through this process, I knew my own work better." Why else would many of America's greatest scientists be willing to spend weeks with Goro, helping him to secure the one priceless image that would set the icon of a subject forever?

His legacy shall be the great understanding that images convey. His monument lies herein, with the same words that Christopher Wren had graven on the floor of St. Paul's Cathedral—*lector, si monumentum requiris, circumspice* (reader, if you are seeking his monument, look around you). His epitaph may be stated in just two words: Fritz Goro—consummate professional.

EXPLORING THE FRONTIERS OF KNOWLEDGE

by Thomas, Peter, and Stefan Goreau

Fritz Goro's photographs are a rare fusion of science, art, and journalism. Goro specialized in photographing the latest developments in science and technology spanning fifty years as a *Life* magazine staff science photographer and free-lance photojournalist. No other individual saw firsthand so many of the groundbreaking discoveries that transformed our century. Goro's images became icons of the modern age.

"Photorealism" is a term used to describe paintings or computer graphics that mimic the "realism" of the photographic image. In Goro's case, the term applies to his images in a deeper sense. He used photography as a tool, pushing it to its limits to expose concealed aspects of reality. His photographs go beyond conventional "photorealism" and show the true features of nature, foregoing the idealizations inherent in computer models or artistic technique. Despite the technical virtuosity of computer graphics, stunning in their perfection and synthetic colors, it is precisely the fine details of photographs that separate reality from idealizations and models to reveal new phenomena.

Fritz Goro was born in Bremen, Germany, the third and last child of Dr. Abraham and Martha Gorodiski. His father was a neighborhood doctor whose medical clinic occupied the downstairs of their home. When the First World War began, Goro was a schoolboy too young to be drafted. His older brother Harald was sent to the front and was seriously wounded in the Battle of the Somme, but survived as a prisoner of war. Shortly after the war's end his father died.

Goro attended the State Art School in Berlin studying graphic design. From there he went to the Bauhaus in Weimar, the new school headed by Walter Gropius that was revolutionizing modern design. While studying at the Bauhaus Goro married the sculptress Margarethe (Grete) Meyer. Bauhaus students intended to shake modern art to its foundations with form and function that stood apart from standard conventions. Like many of his friends, Fritz Gorodiski adopted a nom-de-plume, Goro, to reflect his rebirth as an artist. When hyperinflation in the 1920s forced Goro to withdraw from the Bauhaus before receiving his diploma, he had to go to work.

Armed with his portfolio, Goro went to the leading publishing house in Berlin, Ullstein, and was hired as advertising designer. Soon afterward he became the art director of the *Berliner Illustrierte Zeitung* (BIZ), in charge of layout and design, and the idea man linking editors to photographers. Goro felt limited after a few years and accepted a more challenging position with Ullstein's new magazine, *Münchner Illustrierte Presse* (MIP). While still in his twenties, Goro occupied a central role in establishing modern photojournalism. Zoe Smith's 1986 *American Journalism* article, "Fritz Goro: Emigré Photojournalist," credits Goro with playing an important role in the development of photojournalism by sending photographers like Erich Salomon, Tim Gidal, Martin Munkacsi, and others, to photograph stories for montage layouts, where diagonal elements provided a sense of motion. Goro's layouts escaped the formal, frontal, posed, and framed traditional styles. He made full use of the revolutionary new lightweight Leica cameras that freed the photographer from the cumbersome older models and better captured live action.

In Munich, Goro found a cosmopolitan circle of friends — artists and intellectuals who frequently would get together for exhibits, theater, and conversation. This circle included a motorcycle-riding Jesuit priest, the Crown Prince of Bavaria, Albert Schweitzer, and the paleontologist-anthropologist G. H. R. von Koenigswald. Goro and his staff often ended their day's work at the local beer hall, one corner of which

was the regular hangout of the small group surrounding Adolf Hitler. Locally, educated professionals dismissed this group as fringe lunatics. Hitler, however, was paying close attention to Goro and his colleagues. He regarded himself as an artist. Bitter over his own artistic rejection, Hitler raged violently against modern art, modern design, and photojournalism. As soon as he came to power in 1933, Hitler ordered *MIP* and *BIZ* editors seized as enemies of the state. Goro had become a wanted man.

At this time the Nazis were unable to find Goro, who was recovering from pneumonia in Austria. Grete removed their eight-year-old son, Tom, from school near Munich and headed to a ski resort near the Swiss border. Grete and Tom crossed the border on skis at night, and traveled to Vienna to meet Goro, who had only his Leica and the clothes on his back. He lost his property, books, papers, magazines, and portfolios.

Goro decided to become a photographer, himself, to earn money for food and rent in Vienna, but soon it became clear that the city, swarming with Nazis, was unsafe. The family borrowed money and fled to France. During his short Vienna stay, Goro hired Endre Friedmann, a young Hungarian émigré, as a darkroom assistant. Later Goro would help his career again in France and the United States after the young man became known as Robert Capa. In Paris, Goro started a photographic agency, and began to take the same kind of photographs that he had published in Germany. Many were printed in magazines such as *Vogue*, *Vu*, and the *Illustrated London News.*

With full-scale war ever more likely, Goro sought to emigrate to New York, where much of Grete's family now lived. Despite the sponsorship of Grete's uncle, Max Besas, who emigrated to America as a young man and graduated from Harvard University Dental School, it was difficult to get a visa and impossible to find money for passage. Luck intervened. Goro received an assignment from the French Steamship Company to photograph the new *Normandie*, the largest passenger vessel in the world. His dramatic pictures emphasized the smooth curves and giant size of the ship with unusual photographic angles and antlike sailors for scale. The company was delighted and used the pictures for advertising. In place of payment, Goro requested passage to New York. In early 1936 the Goros set sail on the *Ile de France* for New York, with sixty dollars in savings. Goro's stay in France was an interlude that left a permanent mark. In France he had continued to use his professional nom de plume, Goro, but the French persistently misspelled it Goreau, the Gallic way. Frustrated, he legally changed his name from Gorodiski to Goreau, but continued to use Goro professionally.

On arrival in New York, Goro immediately signed on with the Black Star photograph agency. The agency's roster of photographers included many of his former employees from Germany who fled after their editors were arrested. Goro rented a tiny apartment in Manhattan, converted the bathroom into a darkroom, and got straight to work.

The Goros traveled the length and breadth of the United States photographing a wide variety of subjects for Black Star. They went to the Great Salt Lake in Utah, to Seattle, to Florida, and to rural towns all over New England. This work was accomplished despite a near-fatal disaster. While stepping out of a taxi in Manhattan, another car ran into the door, slamming it closed on Goro's leg. His knee was shattered and the emergency room physician declared only immediate amputation could save his life. Grete refused permission to amputate and demanded another medical opinion. The second surgeon saved the leg, but a long convalescence was in order, and Grete took over Goro's darkroom work, even photographing several assignments.

The photographs that Goro took for Black Star were of famous people, historical events, laborers on the great Depression-era public works construction projects, rural events, architecture, landscapes, natural history, and, for the first time in 1937, science. Goro's discovery of this new subject occurred in Woods

Hole, Massachusetts. While exploring Fisheries Laboratory buildings in Woods Hole, Goro ran into oyster expert Paul Galtsoff, who invited him to look through the microscope. Goro was hooked. He returned to Woods Hole to photograph fish swimming through solutions of Tobacco Mosaic Virus (pages 74 – 75), which revealed under polarized light the stunning development of the gliding fish's smooth wake changing into swirling turbulence as the fish avoided the end of the tank. Fascinated with the visual possibilities and aesthetic richness of the scientific material, Goro resolved to specialize in science photojournalism.

On the way back to New York, Goro visited the Massachusetts Institute of Technology, where he searched the gray corridors for visual inspiration. Amid the warehouses on the fringe of the campus he found a strange, tall tower. Walking through the partly open door, he found himself facing a gigantic pair of metallic spheres atop cylinders (page 44). It was one of the first atom smashers, the Van de Graaff Generator. When charged up to incredible voltages, it generated huge sparks, which accelerated hydrogen atoms to smash into targets at the base, blasting them into fragments recorded by electrical instruments. A man sweeping the floor was happy to climb a long ladder up the side of the shaft to provide a scale for the huge atom smasher. It was Van de Graaff himself, who charged up the instrument and unleashed million-volt electrical bolts for Goro's camera (page 45). Goro was entranced by a world where great physicists built instruments with their own hands and swept up afterward.

Goro in uranium mine near Great Bear Lake, Northwest Territories, Canada, 1946

Many of Goro's science stories shot for Black Star were published by the new *Life* magazine. After the agency had taken its commission fee, there was little left for the photographer, so Goro left Black Star and became the *Life* staff science photographer. Freed from competitive pressure, Goro took time to perfect his images. He was legendary among *Life* photographers for the time he took making each image. They would relate with awe (and perhaps a little exaggeration) stories of Goro disappearing into laboratories for months, sometimes for over a year, to emerge with a single spectacular picture, maybe two or three, recording new advances at the frontiers of science never before seen by the public.

Developments in modern physics captured Goro's attention. He photographed Einstein puffing on his pipe while deriving gravitational wave solutions from the general relativity field equations — one of the few unposed shots of the physicist at work (page 25). Inspired by his visit with Einstein, Goro immediately began an ambitious photo essay on the atom and nuclear physics. Upon hearing of his plans, the Physics Department of Columbia University turned a laboratory over to Goro, where he and his assistant, Bob Campbell, built models of atomic nuclei ranging from the smallest nuclei, hydrogen and helium, to the largest existing in nature, uranium. Each proton and neutron in the nucleus was lit by a separate spotlight (pages 40 – 41). Multiple exposures traced electrons orbiting the nucleus. Many in the group of young physicists with whom they worked later received Nobel prizes. To visualize electrons flying around the atom's nucleus, Goro used an early theory of the atom, the Rutherford model, which had been surpassed in the 1920s by quantum mechanics. In fact, the newer view of electron orbits, as fuzzy probability clouds rather than discrete particles, cannot be clearly imaged using light.

As the world lurched toward war, Columbia University physicists, led by Enrico Fermi, began to pay attention to the possibility that radioactivity and nuclear physics could allow development of an exceedingly powerful bomb. The first nation to have such a weapon would possess a critical military advantage. Fermi and his colleagues wished to split uranium atoms in the laboratory to yield neutrons, which would in turn split other uranium atoms in a self-sustaining chain reaction. They bombarded uranium with neutrons and recorded the subatomic particles flying out of the target on a cathode ray oscilloscope. Goro photographed the blips of light on the screen showing that they had produced fission neutrons in the laboratory (page 46). Fermi and his colleagues celebrated in front of the cyclotron (page 47). The pictures were published in *Life* in 1939, but when the United States entered the war in 1941 their publication became regarded as an unfortunate security breach that might have alerted the enemy of progress toward the bomb.

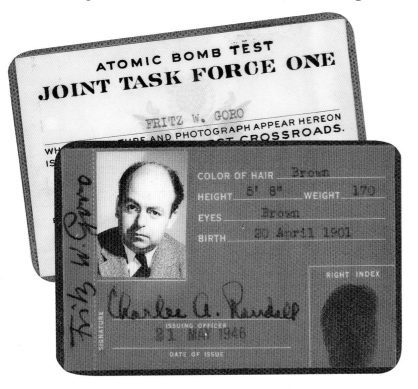

Goro's identification card for the Bikini Atoll atom bomb test, West Pacific, 1946

In 1942 a much larger atomic pile, made of graphite, uranium, and cobalt rods, was built in Chicago. It was designed to absorb neutrons and was based on the earlier Columbia University experiments. The results of these experiments enabled physicists to advance quickly toward the first atom bomb in the top secret Manhattan Project. Through the war years, much of Goro's work was classified on grounds of national security. Many images were published only after the war when the full story of the bomb was revealed.

Goro's series on the atom led to an assignment photographing the new man-made elements created by Glenn Seaborg and his colleagues. Not naturally occurring, these radioactive elements spontaneously break down. They were made in minute amounts in nuclear reactors, followed by painstaking purification through a complex chain of chemical reactions. The first pure plutonium, neptunium, americium, and other artificial elements were visible in the microscope as tiny specks on the end of a spatula (page 48), crystalized salts, or pure metals (page 49), weighing only millionths of a gram, far less than materials previously extracted and weighed. They marked humanity's newfound potential to transform uranium into plutonium, a deadly poison capable of making more powerful nuclear reactors or bombs, and opening the Pandora's boxes of breeder reactors, nuclear waste disposal, and plutonium proliferation.

The first test of an atomic bomb took place at Alamogordo, New Mexico, in July 1945. The bomb was detonated atop a metal scaffold tower in the desert. In August Goro was part of the physics team for the first public view of ground zero. They flew over the bomb site, marked by a shiny circle of desert sand fused into green glass (pages 52 – 53), and landed nearby. They walked to ground zero, where Goro photographed the twisted and melted fragments of the base of the scaffold vaporized in the blast (page 54) and the glass made of fused desert sand (page 54). The two leaders of the project, J. Robert Oppenheimer (the physicist who led the scientific team) and General Leslie Groves (the general who ran the Manhattan Project), stood on

ground zero with only linen socks pulled over their shoes to protect them from radiation (page 55). Goro later made photographs of pitchblende ore from which uranium was extracted. The ore, placed on top of the photographic emulsion, took its own picture as its radioactive particles exposed the film (page 51).

Amazingly, the top brass of the Manhattan Project — and Goro — had been exposed to radiation at levels that would now be impermissible because of the risk of cancer. Atom bombs had been dropped on densely populated Hiroshima and Nagasaki without any real knowledge of the biological effects of radioactivity. The United States Government even denied claims by Japanese physicians that thousands were suffering from radiation sickness. At Bikini Atoll, in the Pacific tests, a variety of animals were exposed to nuclear radiation on the decks of decommissioned warships anchored in the lagoon at various distances from the bomb blast. Goro showed sacrificial animals readied for exposure (page 56), and the horrific results: cancer tumors that consumed a rat's paws (page 57) and a rat's head (page 59). Goro had an exposed rat cut in half, and placed it on a photographic plate to record its radioactivity (pages 58 – 59). The rat's internal organs and bones glowed with radiation.

Goro and assistant, Axel Poignant, in northern Australia, 1950

Goro photographed other areas relevant to the war effort. In an old warehouse laboratory in Cambridge, Massachusetts, provided by the president of the new Polaroid Corporation, Edwin Land, two young chemists re-created a bafflingly complex molecule of great strategic value. It was quinine, antidote to malaria, needed by soldiers in the swampy terrain of the Pacific and Asia. Japan controlled the world's supply, so the chemists set to manufacture it. When Robert Woodward and William Doering finally synthesized the previously impossible quinine molecule, Goro shared their elation as they wrote in their notebooks that they had smashed the Japanese cartel. The war ended before production could swing into gear, but both chemists were awarded Nobel prizes. Land, inventor of Polaroid filters, the instant camera, and other innovations, hired an extraordinary group at the Polaroid Corporation. Prototypes of new films or cameras were often sent to Goro to test. One challenge was to illustrate the optics of the SX-70 Land camera using three laser beams to trace the light path through the folding array of lenses and mirrors (page 38).

Fascinated by the coral reefs at Bikini Atoll, Goro urged his son Tom to take the position of marine biologist on the forthcoming bomb test at Enewetak Atoll. Tom later decided to specialize in coral research. The two built their own underwater cameras, which Goro first used in Bimini, Bahamas, to photograph a wide variety of marine life. Goro also photographed the eye of a hurricane from a navy bomber plane based near Miami (page 16), and the enormous submarine sand waves on the Bahama Banks. By 1950 Goro took his underwater cameras to the South Pacific, while Tom headed to Jamaica to build his own

diving apparatus (SCUBA was still a military secret) and do pioneering research on corals. Goro relied heavily on his son for advice, discussing each project in detail.

Goro spent 1950 to 1951 on the Great Barrier Reef, off the coast of Australia, flying its entire length, taking thousands of pictures from air, land, and underwater. Several were published in a *Life* essay on life in the sea. Goro also photographed the aboriginal people whom he encountered as he moved northward. He headed to Mer, a remote island in the Torres Strait near New Guinea. The people Goro met, almost untouched by outside influence, made their living from the sea with handmade tools. He enjoyed his time spent with them, photographing every aspect of their art, technology, and ceremonies. He later photographed the aboriginal peoples and their art in the Cape York, Arnhem Land, and Ayers Rock areas, traveling across much of the Australian continent. His stay gave him a chance to visit New Zealand and, after decades apart, to see his mother, sister, and brother again. They, too, had escaped from Germany.

The foray from marine biology to anthropology turned Goro next to the Canadian Arctic and the last survivors of the Caribou Inuit (Eskimo). The only inland Inuit, they had once been entirely dependent on the caribou, which they had hunted with stone, wood, and sinew weapons. After contact with the Hudson Bay Company, however, the Inuit had entered the fur trade but also fell prey to contagious diseases. Collapse of the fur trade during both the First and Second World Wars led to their abandonment by traders, leaving the hunters without flour, sugar, tea, or bullets. Having lost the patient craft needed for spear or bow hunting, most Caribou Inuit starved. The survivors fled to Hudson Bay and were housed by the Canadian government. But soon dispirited by life on welfare, they decided to return to their traditional territory, the Barrenlands. Goro lived with them for many months as they tried again to live the traditional way. Tragically, their hunting skills were rusty, illness was persistent, game scarce, and the last of a great people were now too few to survive. Goro and his assistant were left in the Barrenlands by a pilot scheduled to return a month later. On the allotted day the pilot failed to appear. Days, weeks, a month stretched on. Their food was gone, and the Inuit were starving, too. Goro and his assistant were expecting not to survive the winter, when the plane finally arrived. The Caribou Inuit returned to the coast, and within a few years all perished. Afterwards, Goro spent months each year photographing nature in the Arctic and Antarctica.

Through the late 1940s and early 1950s Goro did many photo-essays on the physical properties of matter, producing crystalline images of fire, viscosity, vaporization, density, color photography, and new electronic devices like cathode ray tubes, radar, and television. Goro's career took a new focus with the advent of transistors, solid-state electronics, and lasers. Laser light is in perfect synchrony, unlike previous light sources, where each photon marches to its own beat. At first, this synchrony was only possible in short bursts, but by 1962 a pressurized gas laser gave a blast of pure red light powerful enough to burn a hole through a razor blade. The flying sparks from the melting blade (page 36) symbolized a new race to harness the unprecedented power and precision that lasers now gave to light. Physicists discovered many new types of lasers including ruby crystals, gases, liquid dye solutions, and semiconductors. The first use of lasers in surgery, on the eye of a rabbit (page 37), showed that lasers could operate on the retina without affecting the intervening lens. The method is now routine for humans, saving the sight of millions. Laser devices made astonishingly accurate physical measurements, probed chemical reactions in flames (page 31), stimulated light of precise wavelengths, or triggered vibrations of one type of molecule mixed with many others.

Goro made complex experiments with incense smoke to best allow laser beams to be seen. As Dora Jane Hamblin wrote in her 1977 book on the history of *Life* magazine:

Goro turned out a series of impossibles. One of his most complex was an explanation of how the laser beam works. The pulsed flash of a laser beam lasts only thousandths of a second, yet it can, among other things, perform delicate surgery, clean marble, detect flaws inside masses, go to the moon and come back with measurements of continental drift.

To make all this comprehensible to readers, Goro had to figure out how to show, on one negative, (a) a brilliant light beam, (b) a crystal ruby rod which when struck by the light emits a laser beam, (c) the laser beam itself, (d) an object receiving the beam. The light flash which produced the laser beam was so brilliant that it required hours of experiment, dozens of filters, hundreds of sheets of film, before Goro got it right.

Then the laser beam. Its flash was so fast, so undiffused, that it persisted in being invisible on film. Finally Goro discovered that it was visible in a cloud of smoke, if the smoke was the right density. He and the scientists experimented some more, and built a special chamber into which pulses of burning incense smoke could be introduced. When the tiny blower blew the right amount of incense, the laser beam was visible and the photograph was made. The recipient of the beam in that particular case was a startled looking rabbit which caught the beam in its right eye. It didn't hurt the rabbit.

Goro's smoke methods always worked until he encountered the first laser that emitted light of many colors simultaneously (page 30). For this laser he used a method with flapping white cards that the laser's inventor, Dr. William Silfvast, had devised.

The laser paved the way for the creation of the hologram, a true three-dimensional image. Holograms had been predicted in remarkable work by Dennis Gabor in the 1940s but remained a theoretical curiosity until lasers made them possible. The first hologram was made at the University of Michigan at Ann Arbor by Emmett Leith and Juris Upatnieks in 1963. The inventors, needing a recognizable object in the image, purchased a child's toy train at the neighborhood drugstore. The picture was three-dimensional, but unclear. Goro took one look at their photograph, declared it atrocious, and designed a three-dimensional composition of letters reading HOLOGRAPHY, threading at an angle through a standing sculpture garden of miniature geometric forms. It was the first hologram designed to demonstrate fully and explore the nature of the three-dimensional image (page 34). Goro's *Life* photo-essay revealed how the holographic image was made from the light of four laser beams. Illuminated from two directions by laser beams, the hologram shows the original scene viewed from two different perspectives. Observers of the hologram see the scene shift as they move, allowing hidden objects to come into sight. The hologram plate contains swirls of pigment in patterns unlike the image itself (page 35). Each part contains the information in the whole image, and if the plate were dropped and shattered, the original image could be reconstructed from a fragment.

Goro refined his initial photographic composition for the development of color holography. Early lasers produced monochromatic images, and making laser beams with enough different wavelengths for satisfactory color images was difficult. A breakthrough was made by Stephen Benton, then at Polaroid. His white-light "rainbow" hologram was so named because white light, a mixture of all wavelengths, is used to view the hologram rather than laser light. Each color bends to a different extent, so the eye sees a rainbow succession of red, orange, yellow, green, blue, and violet images rather than all colors at once (page 23).

Engineering advances in the 1960s included semiconductors, computers, solid-state chips, integrated circuits, fiber optics, optoelectronics, laser diodes, and superconducting quantum interference junctions.

Goro on assignment, preparing to fly into the eye of a hurricane, Miami, Florida, 1952

Goro produced the first published images of most of these breakthroughs. His work kept him busy traveling between MIT, IBM, Silicon Valley, and Bell Labs, among other places. Late in life, as infirmity reduced his ability to travel, chip producers would send Goro their latest products to photograph at home. They used his pictures for technical information brochures, advertising, and annual reports. Goro showed the first fiber-optic light guides with light flowing around spools of glass fibers and onto a tooth of a human skull (page 26). The first prism in a light communications circuit (page 32) heralded the beginning of optoelectronics, a technology that may soon allow computers to operate and communicate at the speed of light. Other key developments included the field-effect transistors now used in computers (page 67), ferroelectric crystals used in early computers (page 71), and the superconducting Josephson junctions (pages 68 – 69), which will lead to faster computers in the future.

In the 1970s Goro returned to photographing minute objects, working at his home studio on specimens sent from around the world. To Goro the most interesting were those that pushed the limits of light photography: objects too small or too transparent to be clearly visible, those with important features hidden in a sea of irrelevant background, or those in which only small parts could be seen in focus at once. Photographic emulsion was Goro's canvas, and he never strayed from it—even after transmission electron microscopes allowed far smaller objects to be seen, and scanning electron microscopes brought their previously invisible surfaces into focus. Goro used little-known techniques in which colors generated by polarized light could reveal patterns of fluid flow (page 75), strain in architectural models of Gothic cathedrals (page 29), and internal structure of crystals. Polarized light could paint colorless crystals in fantastic shades, like radiating needles of L-Dopa, a chemical used in treating Parkinson's disease (page 60). When the first moon rocks were brought to earth, Goro used polarized light to show the crystal texture of rocks from the lunar highlands (pages 64 – 65), and those turned to glass by shock waves from meteorite impacts (page 63). He photographed glass spheres produced when impacts sprayed into space molten rock, which froze and fell as a fine glass mist (page 70).

Goro was drawn to the photographing of insects, a difficult task because of the complex nature of macrophotography. Goro took many pictures of insect compound eyes, showing shimmering interference colors produced by light waves reflected from the lenses (page 120). He photographed fossil insects trapped thirty million years ago in amber from the Baltic (pages 112–115). Bubbles, cracks, and impurities in the amber made the fossils difficult to photograph, and subtle control of lighting was needed to capture shimmering light patterns of eyes and wings. Equally amazing were his pictures of scales on butterfly wings (pages 116 – 117), or those of an aphid attached to a wire (page 123), and crawling on a leaf and inserting its proboscis into a single cell to suck its contents.

Microscopic organisms in ponds and estuaries are often transparent. Goro visualized their fine internal structures with color from light interference (page 109). Using a process called Nomarski contrast interference, Goro colored tiny transparent marine fossils so their intricate architecture could be seen (pages 98 – 101). Such fossils are among the hardest to photograph because only a very small part is in focus at one time. Goro also used interference colors to highlight soap bubble surfaces intersecting in various geometries (pages 76–77). One remarkable sequence showed a soap film getting thicker at the bottom and thinner at the top as it sagged due to gravity. Just before it burst, Goro photographed fingerlike patterns on the surface. Similar shapes are now called fractal mathematical structures, but were then unknown.

Interactions between light and life fascinated Goro. He photographed the bioluminescence of the South American "railroad worm," the only organism known to glow in two colors, red at the head, and yellow-green along its body (page 119). Placed directly on the photographic plates, the worms took their pictures by their own light. Goro photographed the response to different colors of germinating seeds (page 127), and made microphotographs of the stomata, the tiny openings in leaves that allow carbon dioxide to enter the leaf and oxygen and water to escape. He showed the fluorescence of the plant pigment chlorophyll, by shining ultra-violet light on the green chlorophyll solution, stimulating it to emit red fluorescent light (page 62).

In uniform solutions of certain reactive chemicals, spiral waves develop and rotate outward resulting in the Belousov-Zhabotinskii reaction. Goro's pictures (pages 72 – 73), taken in the laboratory of Arthur Winfree, are often used to illustrate a novel phenomenon of nonequilibrium thermo-dynamics: the emergence of evolving ordered patterns from featureless mixtures, predicted by mathematician Alan Turing and Nobel physicist Ilya Prigogine. Winfree points out that generation of structures is triggered by energy from external disturbance (shaking the solution), so it is not an example of *spontaneous* generation of structure, which it is often used to symbolize.

Goro continued photographing advances in basic and applied biomedical sciences following his work on the medical effects of nuclear radiation at Bikini. Although disruption of hereditary information in the cells of sheep, goats, and rats exposed to nuclear radiation was clear, the molecular basis of the genetic code had not yet been recognized. In the mid 1950s the Watson-Crick double helix model for DNA explained information storage, replication, and

Goro awaiting rescue, Canadian Arctic, 1954

error due to mutations. To explain the genetic code Goro built a model over twenty feet long, with separately illuminated segments (page 79). The pictures he took (page 78) illustrate the process by which the DNA double helix unzips into two single spirals, each replicating its missing partner and resulting in two separate identical molecules.

To illustrate cellular information processing, in which DNA is used to make RNA copies that are then used to make proteins, Goro used microscopic slides of muscle and nerve fibers, carefully stained to illuminate DNA and RNA in the cell cycle. Some cells have DNA dispersed throughout the cell nucleus, some have DNA bunched in chromosomes, while others show various stages of duplication and division. Human blood circulation was shown by a heart prepared so that all the blood vessels were revealed (page 91). Goro built a novel camera with a very long focal length of one hundred inches, which clearly showed flat red cells tumbling through the finest blood vessels inside the skin of a living salamander (page 91). Later, a striking picture done in the laboratory of Judah Folkman at Harvard Medical School showed a cancer tumor on an eye capturing the organ's blood supply by secreting chemicals that induce blood vessels to grow toward it (page 92).

Vision was a persistent theme in Goro's work, and he photographed detached retinas (page 89), glaucoma damage (page 88), and the eyes of insects (page 121), clams (pages 109), fish embryos (pages 94 – 95), microscopic zooplankton (page 109), and a chick embryo with a third eye implanted by Victor Hamburger, pioneer of organ transplant surgery. Goro illustrated many surgical firsts, which were usually tested on animals. Goro captured the first laser surgery, and the first fetal surgery (page 124): A baby rhesus monkey, removed from the womb of her mother, was successfully operated on and

Goro in the laboratory of Dr. Seymour Benzer, California Institute of Technology, Pasadena, California, 1972

returned to the womb, to be born normally. Decades later, these methods would save human fetuses with congenital malformations — who would otherwise be stillborn or crippled. Goro was horrified by the painful effects of medical experiments on monkeys in space flight experiments and studies of the brain and nervous system, but felt they were a necessary part of medical progress. He did few pictures of human surgery, however, feeling uneasy about photographing people under the knife. He took some of the first ultrasound images of a living fetus in the womb, as well as a miscarried fetus sustained in a tank (page 125). This image, a stark juxtaposition of the "peaceful" fetus floating in artificial amniotic fluid inside a metal and glass "womb," inspired a scene in the film *2001* and is often confused with great pictures taken later by the Swedish medical photographer Lennart Nilsson.

In later years, working at home, Goro played with light sources, lenses, chemical dyes, and interference to bring out subtle features in thin sections of tissue preserved between glass slides. He created a portfolio of pictures including the cartilage of a rat's knee (page 87); cancerous cells from a Pap smear (page 87); spherical fat cells (page 87); white blood cells detecting, surrounding, and attacking a foreign object identified as a target by the immune system (pages 86); and the first successful tests using interferon against

cancer. The first cloning of a whole plant from a single carrot cell (page 126), grown on agar in a lighted glass tube by Francis Steward at Cornell, revealed the start of plant tissue culture technology, which has revolutionized our food supply. The role of hormones in reproduction was illustrated with sex-changing lizards and cows stimulated by fertility hormones to bear twins. Blue dye showed the separate placental fluid supply that each calf embryo received (pages 122 – 123). Goro worked with pioneers in artificial fertilization like Pierre Soupart and Yu-chih Hsu. He used Nomarski contrast interference optics to show cells fusing together (page 83) and early embryonic development of an artificially fertilized mouse (page 81), before fertility enhancing techniques were widely used on humans.

Some of Goro's most difficult photographs dealt with nerves, neurons, and information processing in the brain. Networks of nerve fibers in the brain are extremely complex and are so minute that microscopes allow only small parts to be seen in focus at one time. His photograph of a neuron in the brain's visual cortex with a nearby microelectrode (page 93) has become a classic. It was taken in the Harvard Medical School laboratory of David Hubel and Torsten Wiesel, who received Nobel prizes for their work on visual perception. David Hubel recalled years later how extraordinarily difficult that picture had been to capture; he marveled at how Goro had managed to focus in on the critical neuron lost amid a dense tangle of nerve fibers. Another neurophysiologist, Walle Nauta, on viewing Goro's pictures of his own research slides, was astonished that extraordinary subtleties in the distribution of chemical stains revealed minute structures that had long been suspected but never before seen.

Goro received many honors late in life. Awards came from the American Society of Magazine Photographers (he was elected to the three-man board of trustees at the first annual meeting in 1945), the Biological Photographers Association, and the New York Microscopical Society. He lectured at Yale University, in a course initiated at the request of students, and was named to professorships at the University of California at San Diego and at the State University of New York at Stonybrook.

In California, at the Scripps Institution of Oceanography, Goro photographed Project Mohole, the first deep-sea drilling project to excavate the ocean crust and decipher its history. He covered every aspect of the pioneering expedition: the unusual ship designed for deep ocean drilling; miles of drill pipe stacked ready to be attached to the diamond drill bit; the exhausting job of wrestling the drilling rig into place; concern over whether the equipment would work as planned; exultation of the crew as the first cores were returned; and exhilaration of scientists who cut the core open, scooped out the first material, and examined the deep-sea microfossils to determine their age (page 105).

Goro became close friends with many oceanographers, and sailed on the *Alpha-Helix*, a tiny floating ocean research vessel, to the fjords of British Columbia with Per Scholander, Andy Benson, and others to study dramatic changes in Pacific salmon. He captured the metamorphosis of salmon that migrate up mountain streams to spawn, aging rapidly and dying while their beautiful eggs hatch (page 110). En route he showed the microscopic zooplankton food of the juvenile salmon. These little copepod shrimp contain globules of wax and fat colored red by pigments from the tiny algae they eat, which are absorbed all the way up the food chain to the salmon.

Despite the pleasure he derived from working with interesting scientists, Goro was unwilling to accept offered positions that came late in life. His wife was ill and needed constant care, and his injured knee increasingly affected him until it required replacement by an artificial joint. Using a walking stick to get around, Goro worked until his mid eighties. Finally, untreatable cancer slowly wore him down, leaving his mental vigor and range of interests undiminished until his death on December 14, 1986. He left a legacy that will always be treasured by those who seek to visualize the frontiers of knowledge.

LIGHT

Light is radiant energy. Bathing the universe, it is composed of oscillations of electric and magnetic fields that come in a continuum of lengths from very short energetic gamma rays to very long low-energy radio waves. Visible light occurs in a narrow range of wavelengths less than a millionth of a meter long. Light displays the behavior of all waves, undergoing reflection, refraction, and diffraction, but also has particlelike properties in interactions with matter. This particle-wave duality gives rise to the modern notion of photons, or quanta of light energy.

Light travels at 186,000 miles per second in a vacuum (299,793 km/sec), a fundamental universal constant. White light is a mixture of all different wavelengths or colors, with violet light the shortest and red the longest. In certain media such as glass and water, the speed of light varies with wavelength. This gives rise to dispersion, making each wavelength bend to a different degree, producing the familiar rainbow and spectrum. When light waves interact with one another they may add or subtract, giving rise to interference colors. These evanescent colors vary with each slight change of the viewer's position, as in shimmering insect wings or oil film on water. They result from interference of light waves bouncing off suitably spaced surfaces, and are not colors of the surfaces themselves.

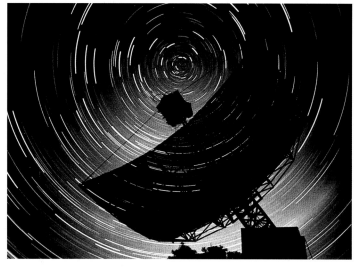

Radiotelescope and Rotating Sky.
The first radiotelescopes built to monitor radio waves from space were fixed, and relied on the rotation of the earth to orient them. This time exposure shows curved tracks of stars around the South Pole caused by the earth's spin around its axis. Sydney, Australia, 1951.

Sky and Rotating Radiotelescope.
This later radiotelescope at MIT's Lincoln Labs Haystack facility had a steerable parabolic dish, capable of mapping a larger area of space to higher resolution. Millstone, Massachusetts, 1958.

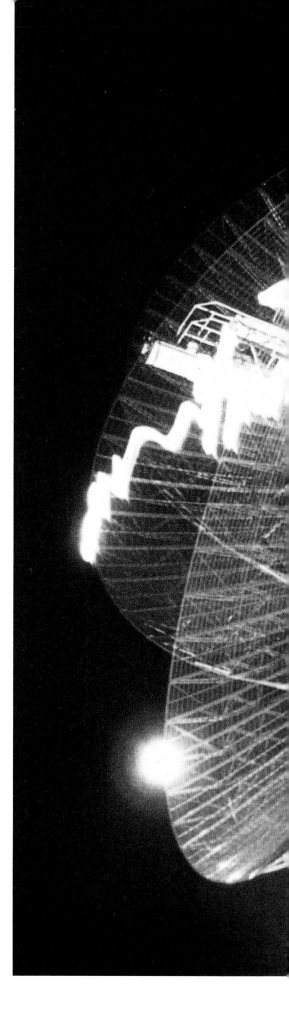

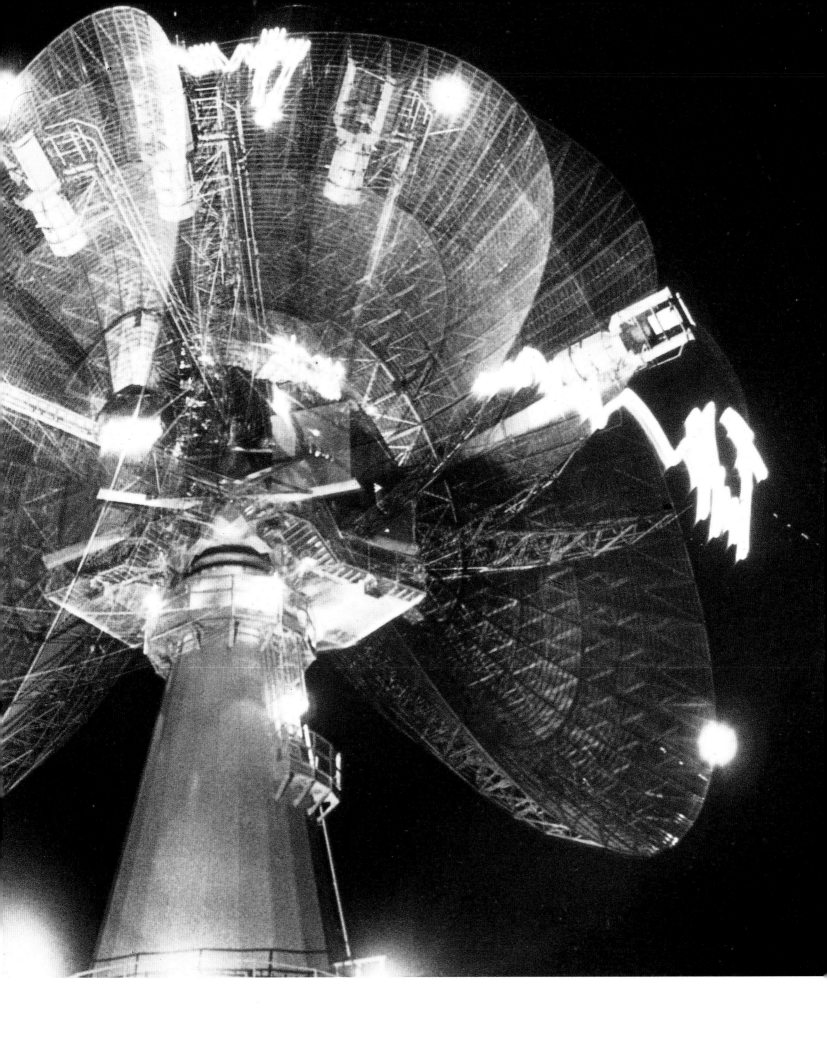

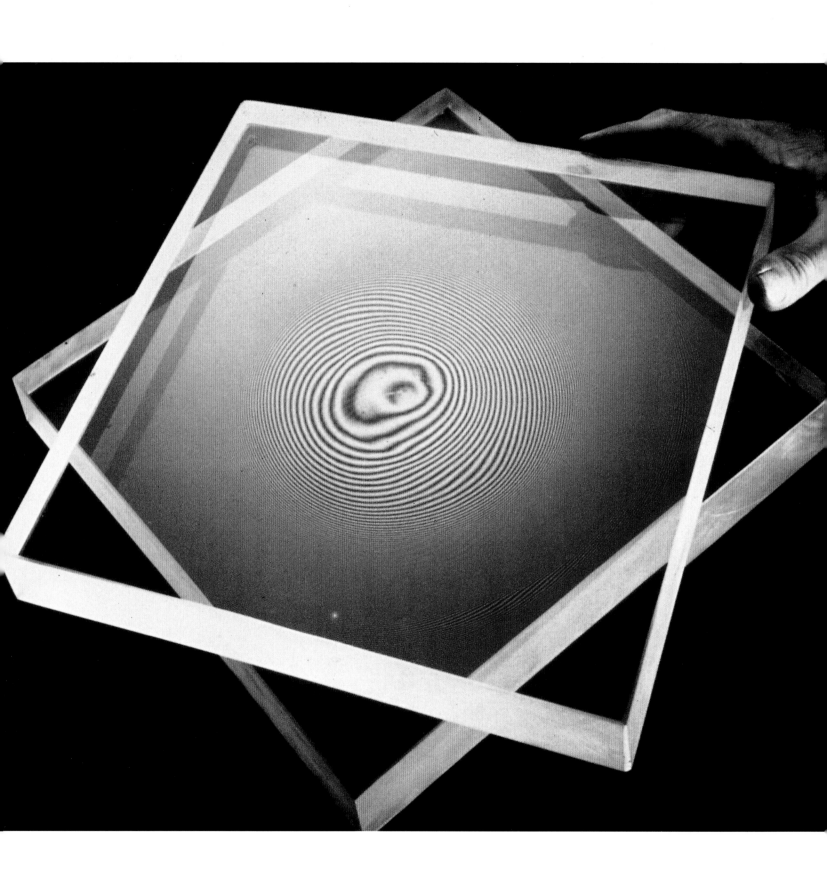

Newton's Rings.

Dark rings mark the locations where light waves reflected from the top and bottom of a lens cancel each other through interference. Variations on these patterns allow lens makers to determine how uniformly a glass surface is being ground. Taken at the Bausch & Lomb lab. Rochester, New York, 1944.

Light interacts with matter, in particular with electrons, which capture photons, converting them into kinetic, electrical, or heat energy, and also sometimes into light of longer wavelength. Light serves as the medium of information exchange by which matter in one place affects matter far away. Some materials absorb all light except that vibrating in a single orientation. This polarized light is responsible for some beautiful images where extremely subtle natural patterns and forms are revealed. On transmission through certain crystals, liquids, or gases, polarized light undergoes rotation. When viewed through another polarizing filter, bright colors can result that depend on the original orientation of the light, and the molecular orientation of the transmitting medium.

A laser supercharges electrons in ways that force them to emit excess energy in a single intense burst. This produces coherent light, in which all photons vibrate in perfect phase with one another. Lasers allow unprecedented light energy to be focused on tiny areas and also the creation of three-dimensional holograms.

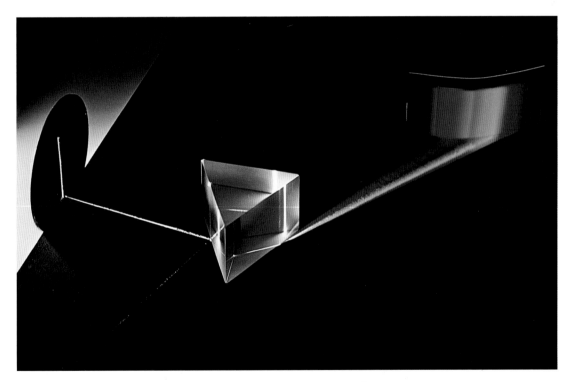

The Spectrum.

White light hitting a prism is refracted to form the visible light spectrum. The photograph was taken with the help of Herbert Goldberg and Walter Litten of the Eastman Kodak Research Lab. Rochester, New York, 1944.

Einstein's Gravitational Wave Equations.

The page of Einstein's notebook where he derived the gravitational wave equation. Although theoretical physicists are satisfied with Einstein's proof of the existence of these waves, they have yet to be experimentally detected. Princeton, New Jersey, 1938.

Albert Einstein.

Albert Einstein working in his study on the theory of gravitational waves, shortly after being exiled from Germany by the Nazis. Princeton, New Jersey, 1938.

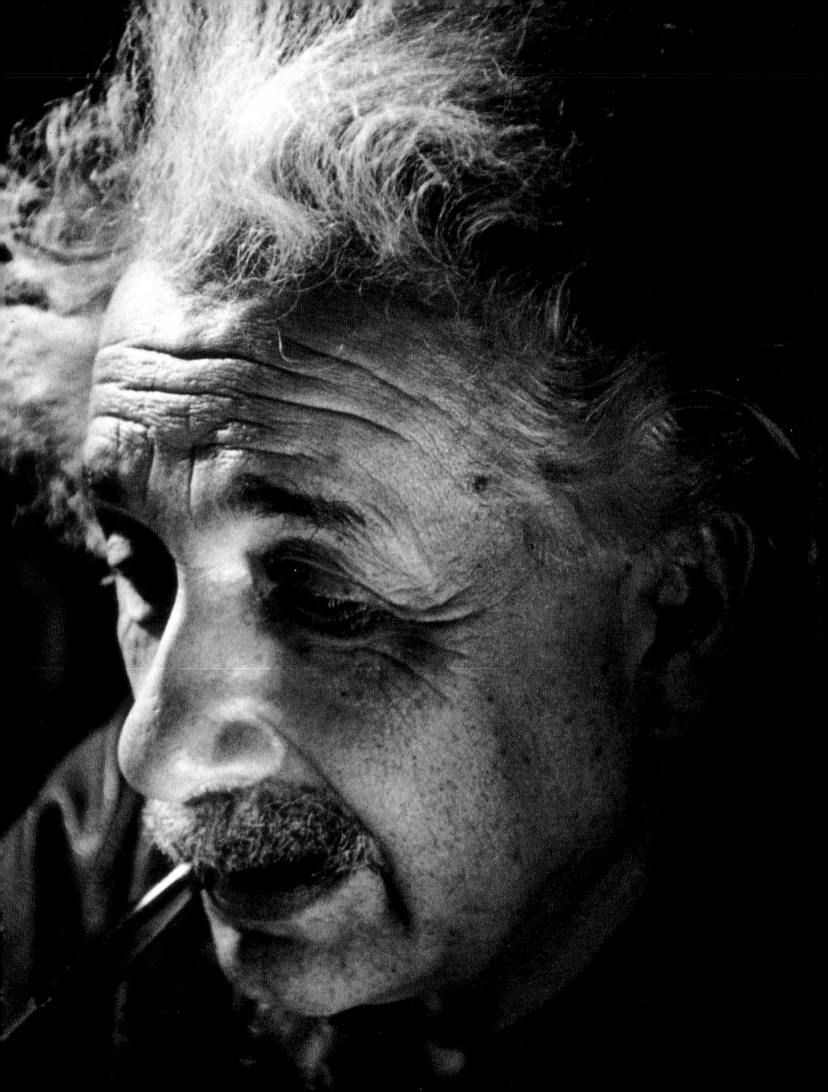

Fiber-Optic Light Pipe.
One of the first fiber-optic cables for transmitting light long distances around curves. This technique has since become the basis for a revolution in optical information processing and in tools for imaging the body's interior. Bell Labs, New Jersey, 1969.

Fiber Optics on Skull.
Intense light focused on a tooth by a light guide. This is one of the first applications of fiber optics, now commonly used by surgeons to illuminate internal organs when operating. This technique allows the surgeon to transmit light into hard-to-reach places. Bell Labs, New Jersey, 1969.

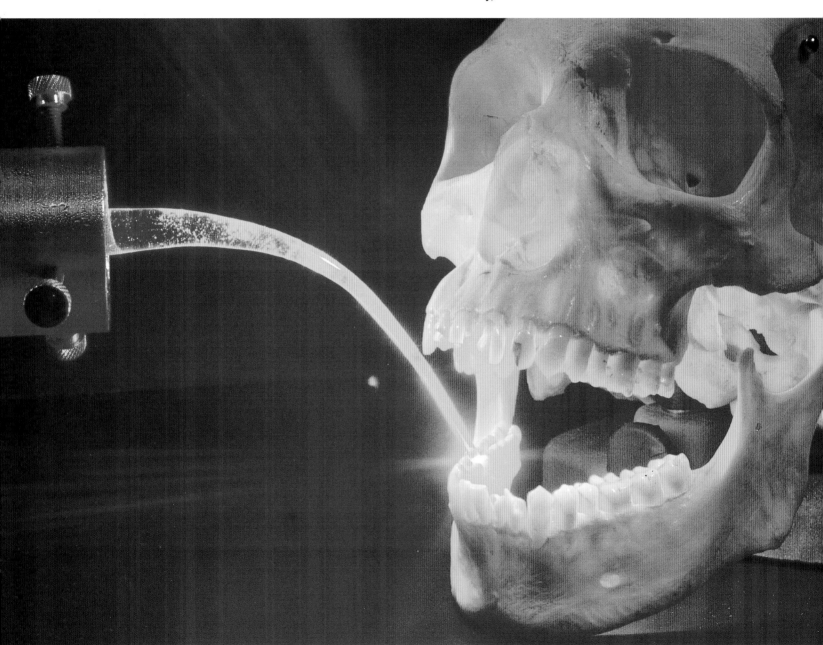

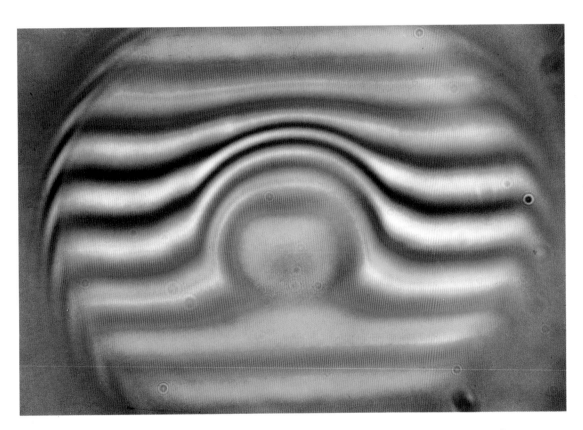

Interference Fringes in Fiber-Optic Light Guide.

Fiber-optic light cables are capable of transmitting vast amounts of information. This fiber has been made so that the parallel light fringes entering the far end have been focused toward the edges. Fiber-optic technology has greatly increased the quantity and accuracy of information transmitted by telephone and computers. Bell Labs, New Jersey, 1973.

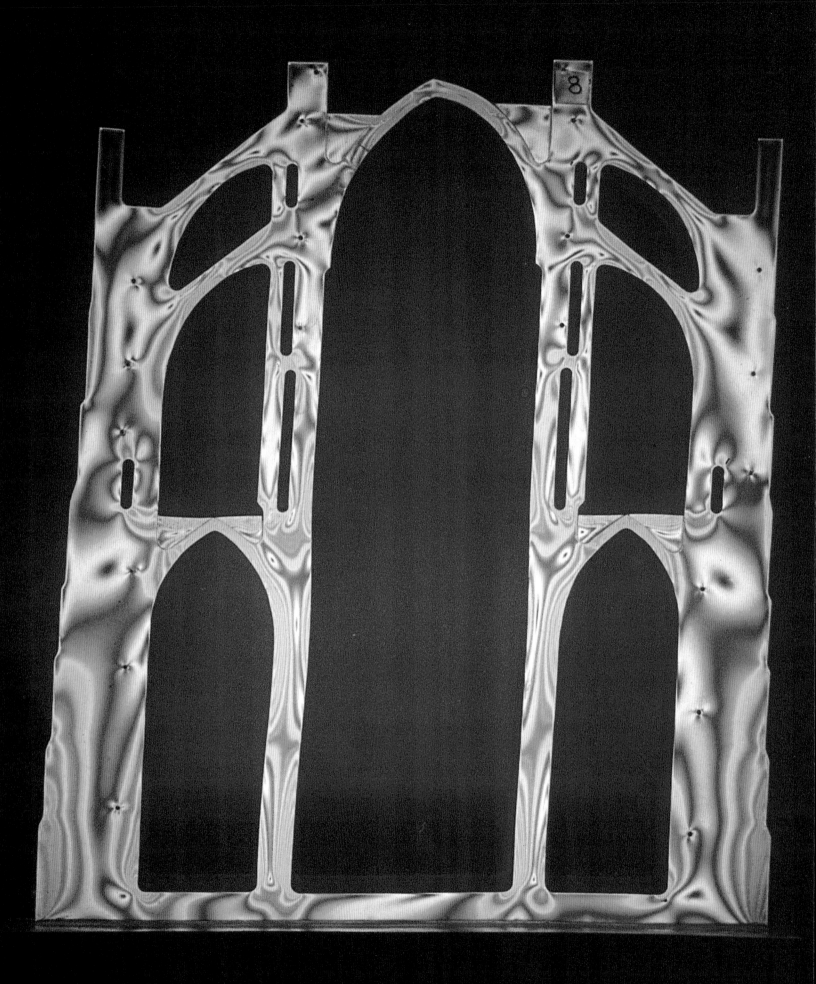

Strain in a Gothic Cathedral.
Polarized light shows the distribution of strain in the flying buttresses of a
cross section of a Gothic cathedral. Princeton, New Jersey, 1969.

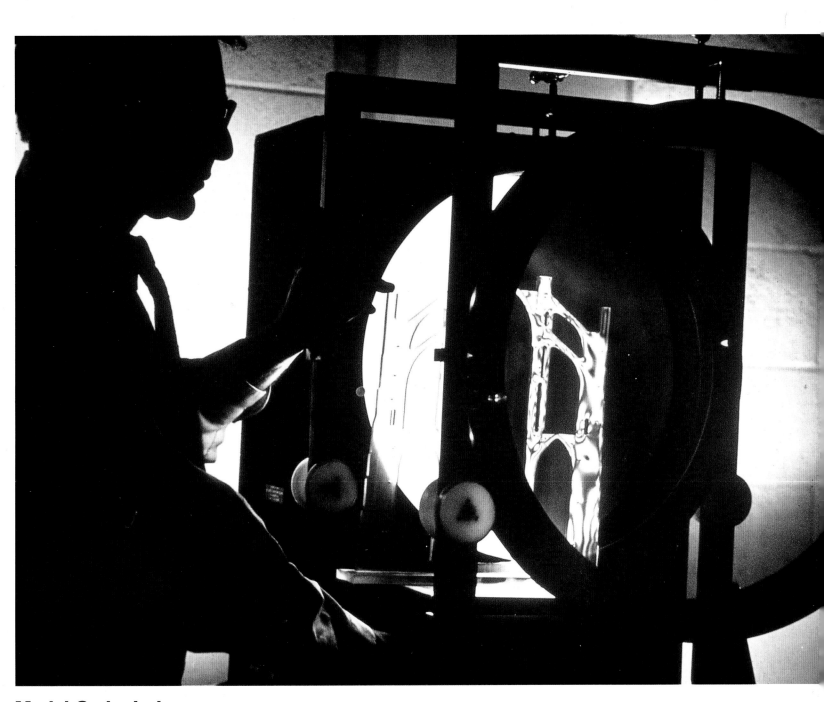

Model Cathedral.
Dr. Mark Little, architect, with model showing how polarized light reveals
invisible stress patterns in a Gothic cathedral. Princeton, New Jersey, 1969.

Multicolor Laser.

This laser, developed by Dr. William Silfvast at Bell Labs, was the first to emit light of many colors. The laser beam, entering from the left, hits a diffraction grating, generating several sets of spectral lines. Bell Labs, New Jersey, 1973.

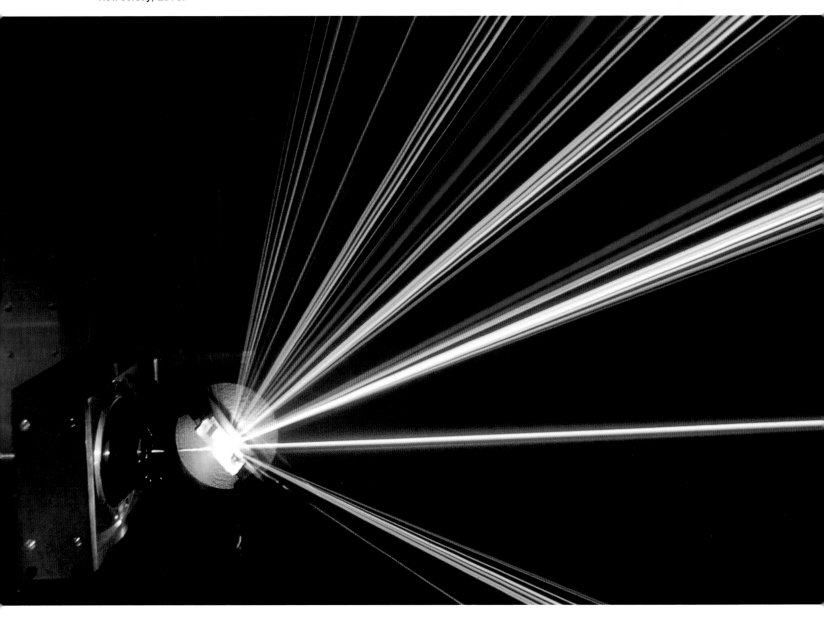

Chemical Lasers.

The blue laser beam excites green fluorescence
from soot forming in the flame. Fire Research
Center, National Bureau of Standards, 1982.

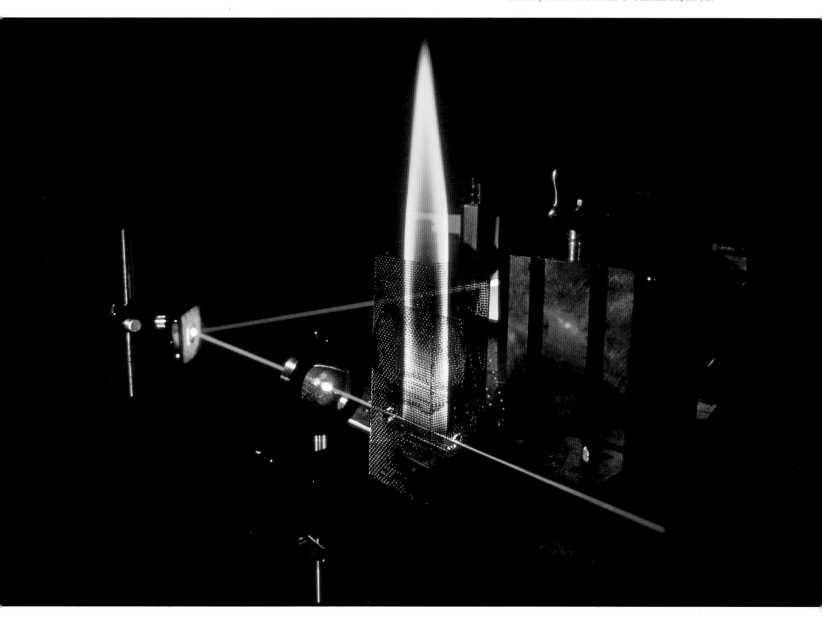

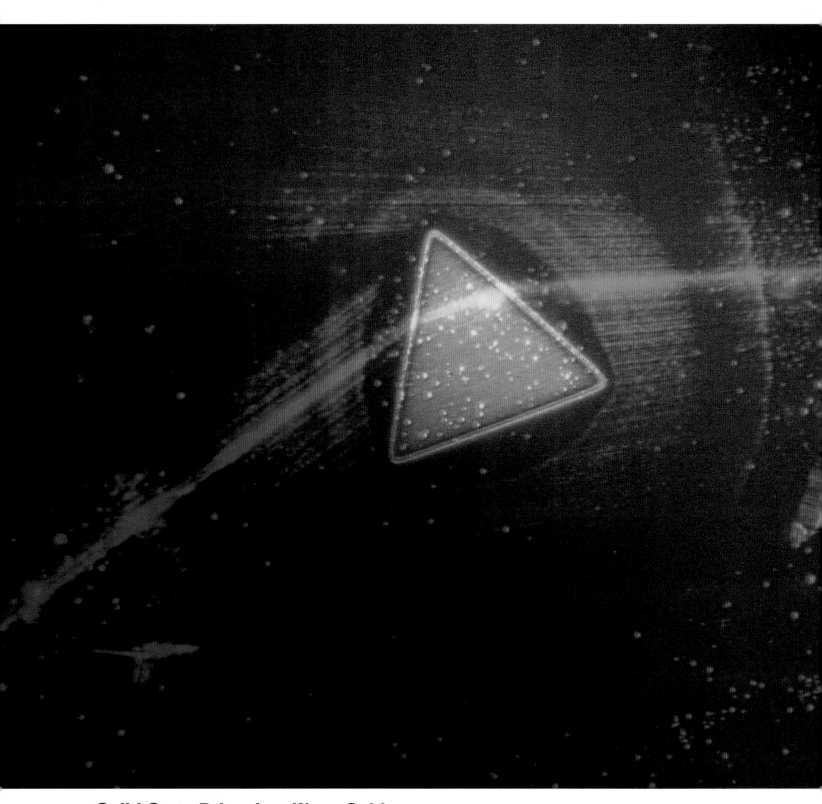

Solid-State Prism in a Wave Guide.

A laser beam is bent by a microscopic prism. The prism is only a few
thousandths of a millimeter thick. These methods may allow for the
development of computers based on transmission of light waves instead
of electrons. Laboratory of Dr. P. K. Tien, Bell Labs, New Jersey, 1974.

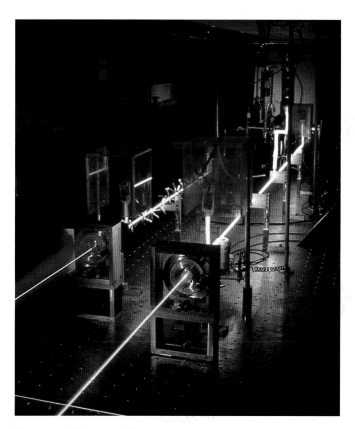

Laser Beam Apparatus.
Blue helium-cadmium and yellow helium-selenium lasers. Laboratory of Dr. William Silfvast, Bell Labs, New Jersey, 1973.

Holographic Art.

The first hologram, of a toy train, was made by Emmett Leith and Juris Upatnieks at the University of Michigan. This hologram, designed shortly afterward by Goro, Leith, and Upatnieks, illustrates the three-dimensional nature of the hologram image seen from two directions and is regarded as the first example of holographic art. Ann Arbor, Michigan, 1966.

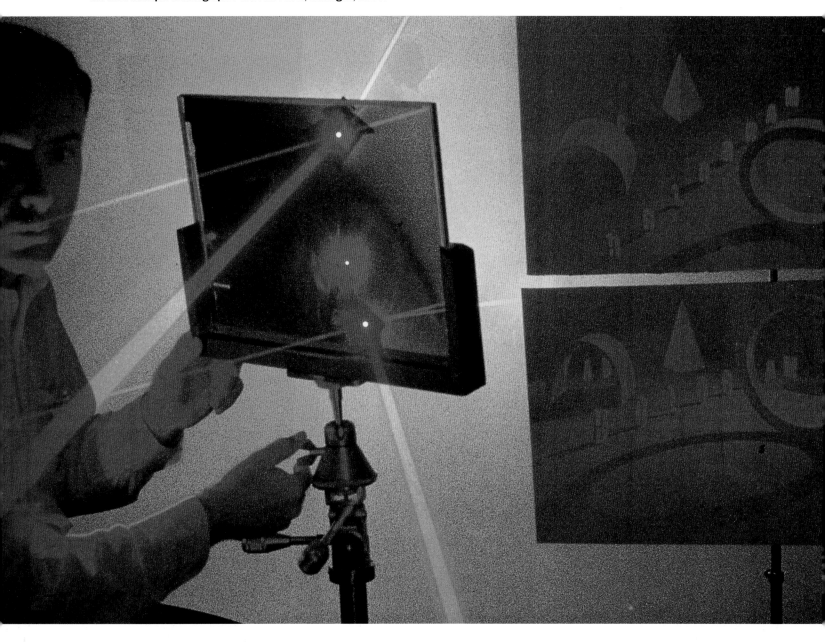

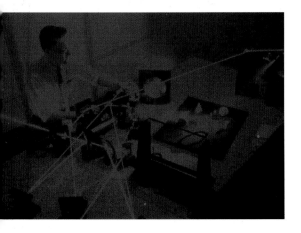

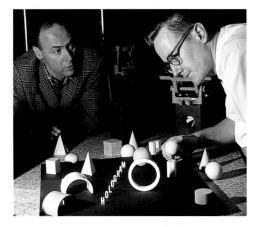

Fritz Goro worked on this project at our laboratories for four or five weeks. The trick was to make a scene that would look three-dimensional even when photographed with the ordinary camera that gives a flat image. After about two weeks of intensive effort, he came up with the scene shown. Although the figure shows myself and Emmett Leith, the layout was entirely Fritz Goro's. In this scene, evidence of the three-dimensional recording properties of the hologram is provided by the letters ABC, visible from one position but not from another. Goro was a perfectionist and worked very diligently until the images could no longer be improved.

<div align="right">

Juris Upatnieks
Adjunct Associate Professor of Electrical Engineering and Computer Science University of Michigan

</div>

Hologram Plate.

The resulting holographic plate is a photographic emulsion with seemingly indecipherable swirls resulting from the interference of the two laser beams. If the plate is illustrated by a reference laser beam at any spot, the entire three-dimensional image is visible. This would remain true for any fragment, even if the plate were to be dropped and shattered into a hundred pieces. Ann Arbor, Michigan, 1966.

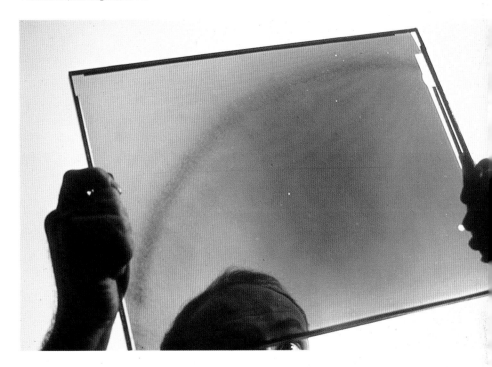

A milestone in display holography was the construction of the first artistically respectable hologram, at least the first one that had come to my attention. Fritz Goro in 1969 did a story on holography for Life *magazine. He visited our laboratory and viewed our holograms for their possible use in the magazine. He affirmed that our holograms were technically superb, but added that they were artistically atrocious, a fact that we had ourselves long suspected. He then proceeded to design a hologram scene that would be, if not a work of art, at least one that had some artistic merit. The scene was simple, but showed all the exciting properties of holograms, and even looked somewhat three-dimensional when printed in the magazine as a conventional photograph.*

<div align="right">

Emmett N. Leith
Professor of Electrical Engineering and Computer Science University of Michigan

</div>

Holographic Laser Setup.

The laser setup in the University of Michigan laboratory of Drs. Leith and Upatnieks, during the taking of the hologram. The laser beam is split into a reference beam that undergoes optical interference when recombined with a beam reflected from the holographed object. Ann Arbor, Michigan, 1966.

Laser Beam Vaporizing a Razor Blade.

The rapid development of intense, focused bursts of coherent light in laser beams was exploited for industrial purposes such as welding. Here a laser beam melts its way through a razor blade, an experiment that led to today's robot welding machines. Ann Arbor, Michigan, 1962.

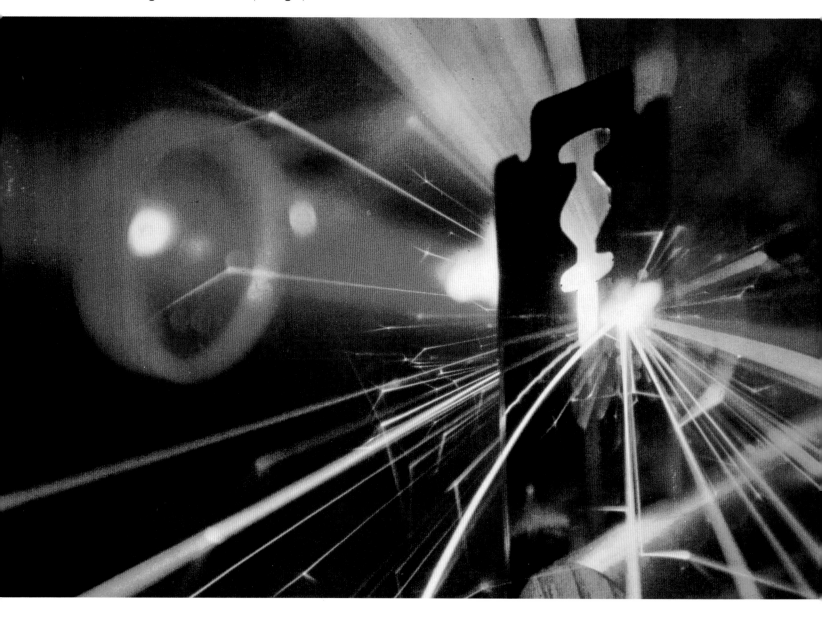

First Laser Surgery.

The first use of laser beams in microsurgery was pioneered in experiments on rabbits. Here a laser beam cauterizes a small blood vessel in a rabbit's eye at Long Island Jewish Hospital. These techniques allow precise removal of small volumes of damaged tissue without harm to neighboring tissue, and have since become standard surgical tools. Long Island, New York, 1962.

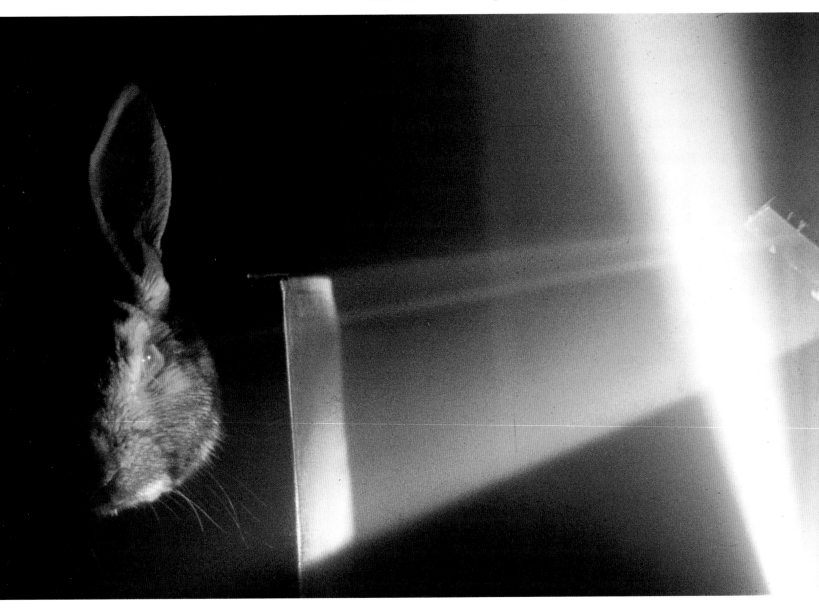

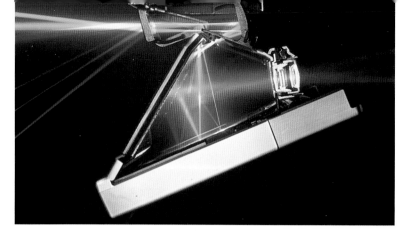

SX-70 Land Camera.

A cross section of a Polaroid model SX-70 Land Camera showing the path of three laser beams through the camera optics. Polaroid Labs, Cambridge, Massachusetts, 1972.

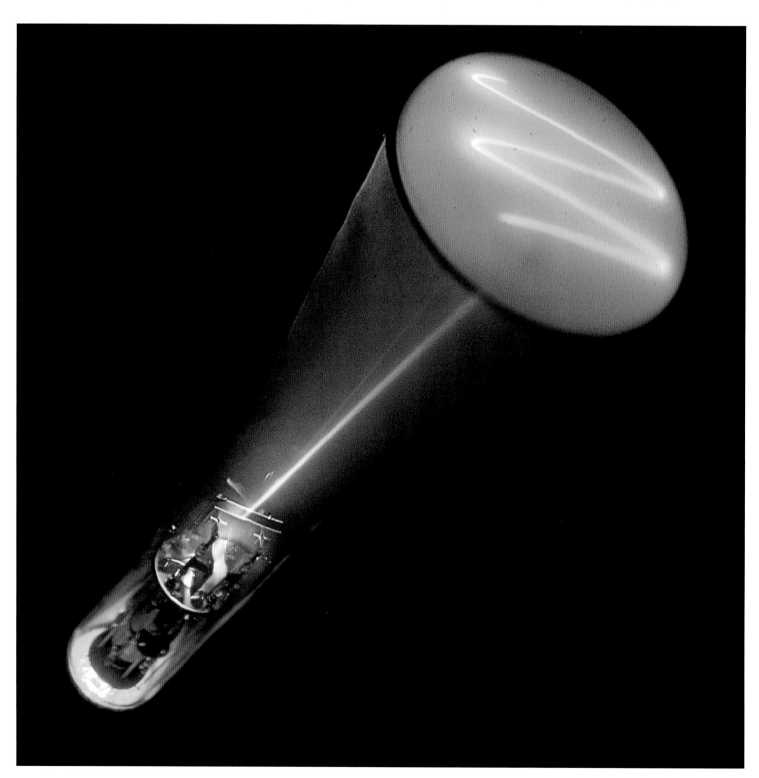

Uncoated Lenses and Coated Lenses.

Top: A cross section of compound lenses in a camera shows light scattering from uncoated glass surfaces, *Bottom*: and their suppression by a thin antireflective surface coating on the lenses, greatly improving the image.
Goro Studio, New York, 1944.

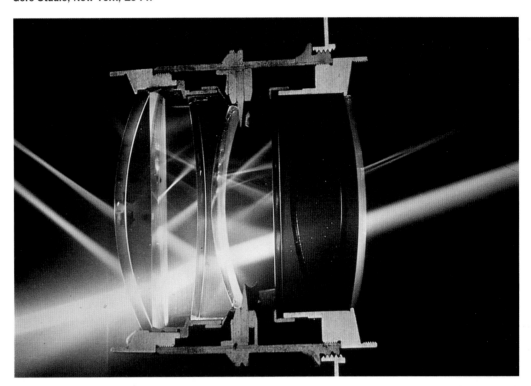

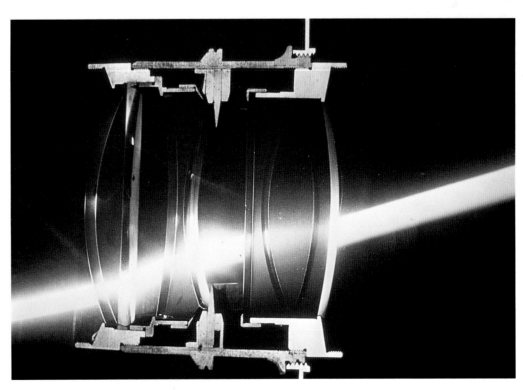

Cathode Ray Oscilloscope.

Left: Variations in the electric charge applied to plates focus an electron beam onto phosphorescent light-emitting crystals on the screen, illustrating the principle by which television and computer screens create images.
Goro Studio, New York, 1945.

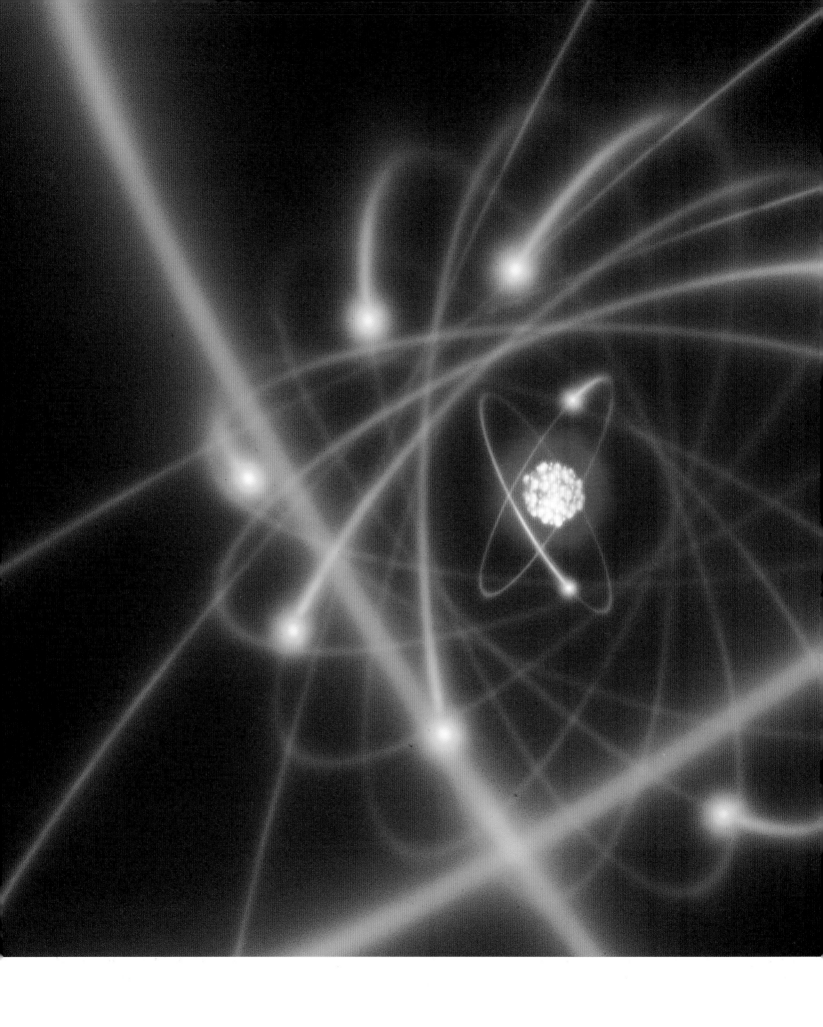

ATOMS

Atoms are elemental matter. Long thought indivisible, they are now known to consist of subatomic particles including electrons, neutrons, and protons. Atoms are strongly bound energy states occupying space, and are the site of charge, inertia, and mass. They appear to be predominantly open voids with intensely concentrated regions of resonant energy. At the center lies the nucleus, made up of positively charged protons and neutral neutrons. Like planets around the sun, the negatively charged electrons vibrate, rotate, and spin in shifting conformations around the nucleus.

Atoms come in approximately one hundred distinct types. These elements can have several different masses or isotopes, depending on the number of neutrons in their nucleus. The properties of atoms are dominated by the number of protons in the nucleus and the geometries of outer electron orbits.

Most matter in the universe consists of hydrogen, the simplest atom; with the exception of some helium, the next lightest element, heavier elements were originally forged from hydrogen inside stars at extremely high temperatures and pressures. These conditions fuse small nuclei together, forming heavier elements that are released to space when stars explode. Younger stars, like our sun, are enriched in heavier elements when they form from cosmic gas mixed with dust ejected from their predecessors.

Of all naturally occurring elements, uranium is the heaviest. But it is also unstable, and with time its nucleus can spontaneously change, forming new elements and emitting radiation. This radioactivity includes gamma rays and a host of subatomic particles and nuclear fragments.

Under the right conditions, radioactivity can be harnessed to produce atom bombs or nuclear power, but it always generates radiation with harmful effects to living organisms. Particulate radiation can also be harnessed to convert uranium into artificial elements like plutonium. These have nuclei that are even heavier than uranium, but they are highly radioactive and decay so quickly that none are found naturally.

Uranium Atom.

This classic picture has become an icon of the nuclear age. Taken from over thirty superimposed exposures, it represents the electrons in discrete orbits around a central nucleus of neutrons and protons. This view of the most complex atom found in nature represents nuclear theory in the early 1920s, before quantum theory reduced the electron to delocalized probability clouds. Goro Studio, New York, 1949.

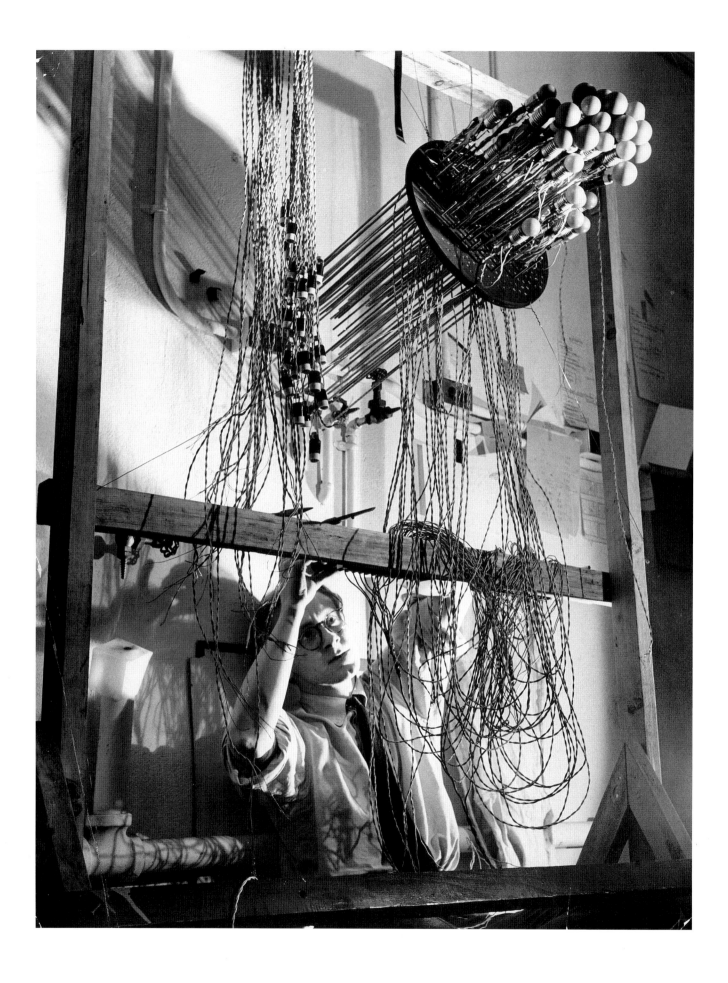

Model of Uranium Atom.

The mass of lights and wires that made up
the model of the uranium atom. This complex setup
owed a great deal to the ingenuity of Bill Havens. It
was made in a special studio constructed in a physics
laboratory at Columbia University. New York, 1949.

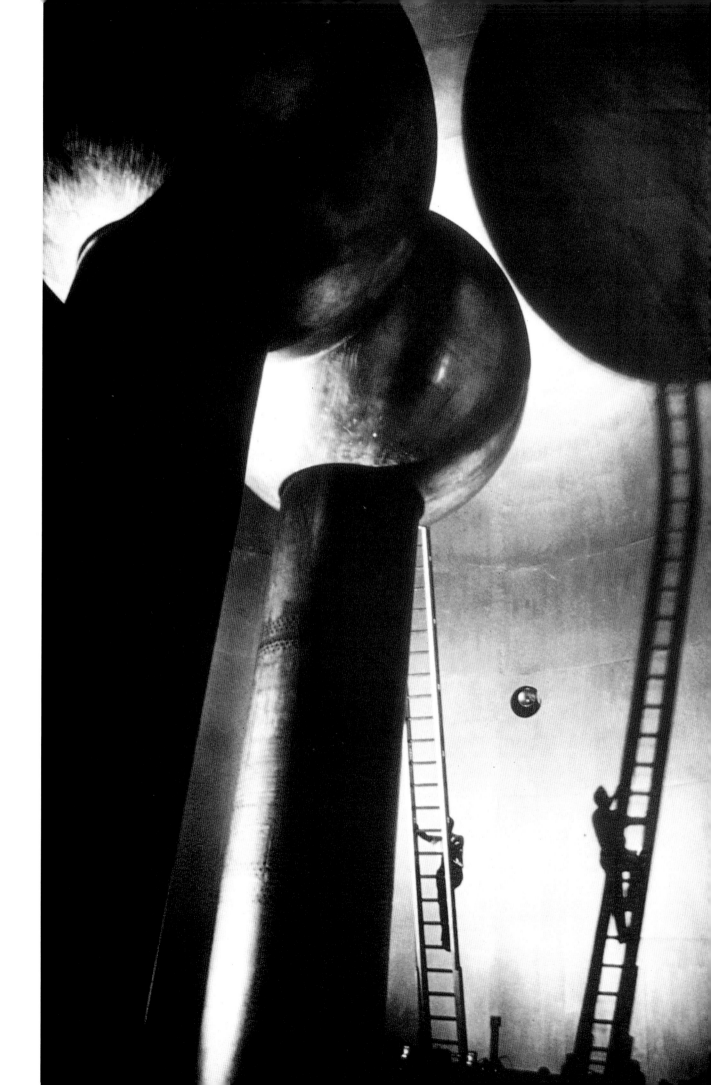

Atom Smasher.

The Van de Graaff Accelerator, one of first atom smashing machines, stands in a huge dome-shaped building at MIT. Wandering into the building by chance, Goro found it deserted except for a man who was sweeping dust off the floor. It was Dr. Van de Graaff himself, who, delighted to show his invention, is climbing the ladder to the giant high-voltage spheres. Cambridge, Massachusetts, 1937.

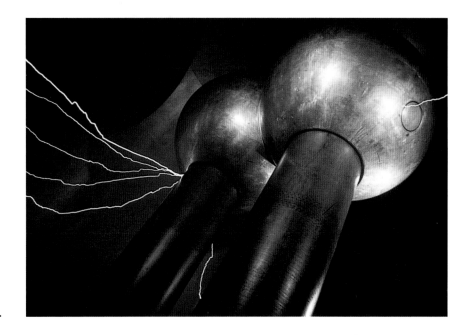

Spark Discharge of Van de Graaff Accelerator.

Intense high-voltage sparks were used to accelerate ions into targets at the base in early atom smashing experiments at MIT. Cambridge, Massachusetts, 1937.

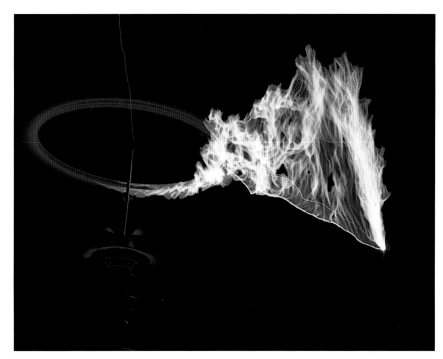

Electric Arc Discharge.

A million-volt alternating current discharge at the Westinghouse Corporation. Trafford, Pennsylvania, 1945.

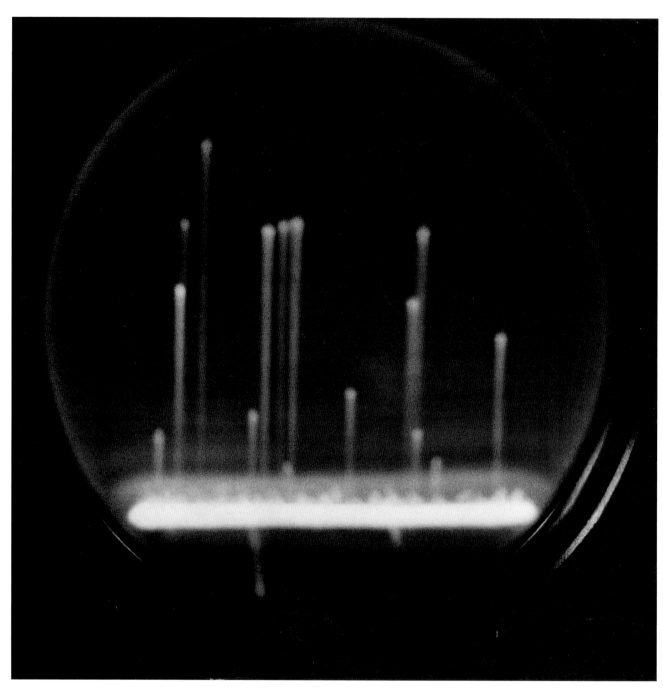

Nuclear Fission Energy Release.

This historic cathode ray oscilloscope shows energetic neutrons
released by uranium fission in the Physics Department at Columbia
University. New York, 1939.

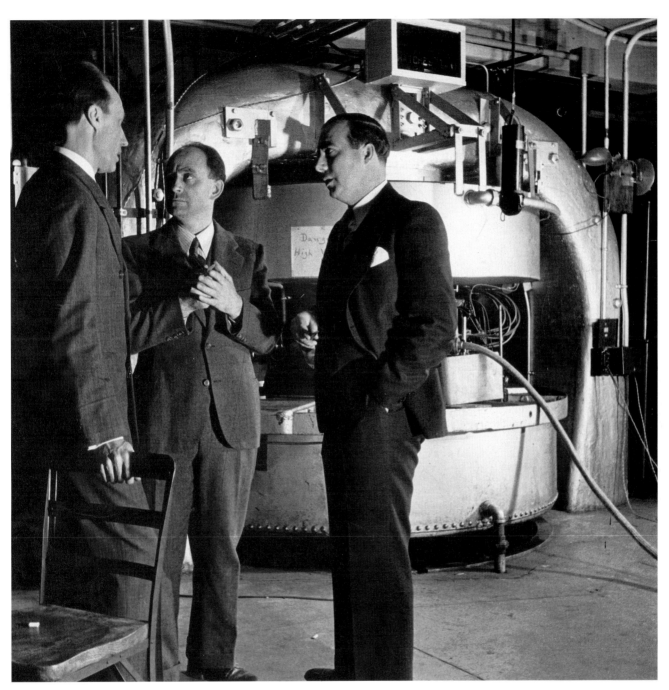

Enrico Fermi and Cyclotron.
The brilliant Italian emigré physicist (center), in the early
stages of work that led to the development of the first
nuclear reactor and the atom bomb. Columbia University,
New York, 1939.

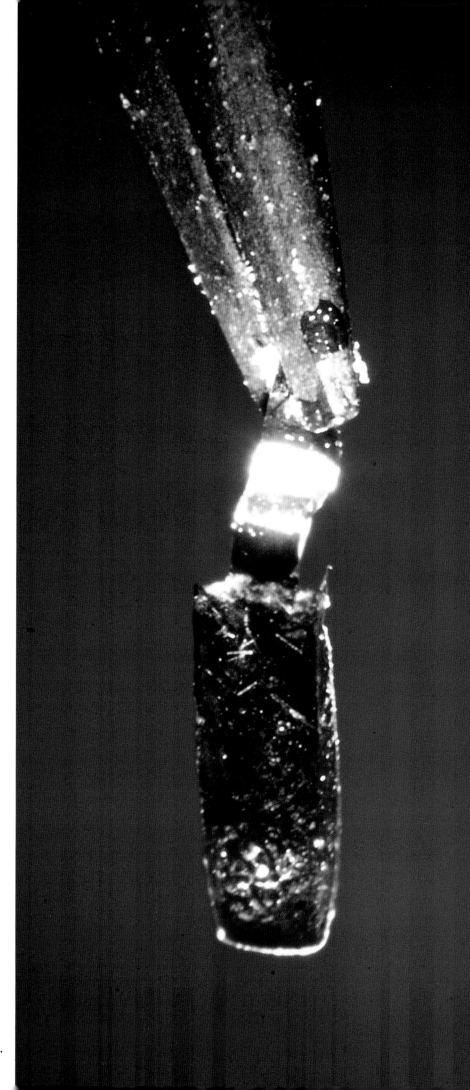

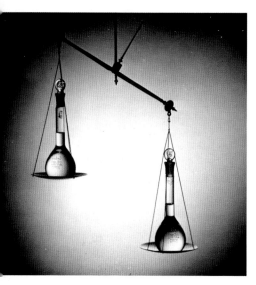

Heavy Water.

Heavy water, in which normal hydrogen atoms have been replaced with an isotope weighing twice as much, tips the scale away from an equal volume of ordinary water. Large amounts of heavy water were prepared as a neutron moderator in the first nuclear reactors. Goro Studio, New York, 1939.

A.

Fritz Goro visited us in June 1946 to take pictures of the apparatus we employed in the plutonium section of our metallurgical laboratory. He was able to photograph successfully the ultra-microchemical equipment, including the tiny containers, the quartz fiber balance used to weigh the plutonium, and the plutonium itself. This was an extraordinary achievement; at the time, we described it as weighing an invisible sample with an invisible balance.

Glenn T. Seaborg
Nuclear Science Division
Lawrence Berkeley Laboratory
University of California, Berkeley

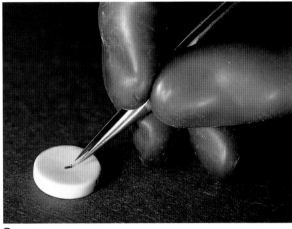

B.

The First Man-Made Elements.

The first samples of new man-made transuranium elements produced by neutron irradiation of uranium in the first breeder nuclear reactors. At the time, these samples were regarded as finally achieving the ambitions of the ancient alchemists to transmute the elements. Chicago, Illinois, 1945.

A. The sample coating the tip of a microscopic spatula.
B. The first 2.77 millionths of a gram of plutonium to be weighed.
C. Crystals of the first neptunium to be purified.
D. Plutonium metal.

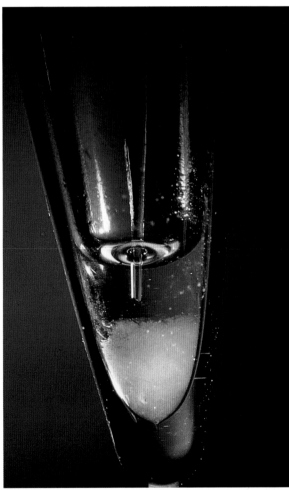

C.

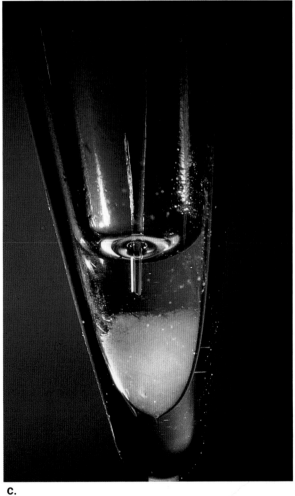

D.

Pitchblende Ore Used in the First Atom Bomb.

Uraninite (pitchblende) ore crystallized billions of years ago in rounded masses along cavities and crevices in rocks. They were deposited from hydrothermal waters heated by volcanism from the earth's interior in what is now the Canadian Arctic. El Dorado Mine, Great Bear Lake, Northwest Territories, 1946.

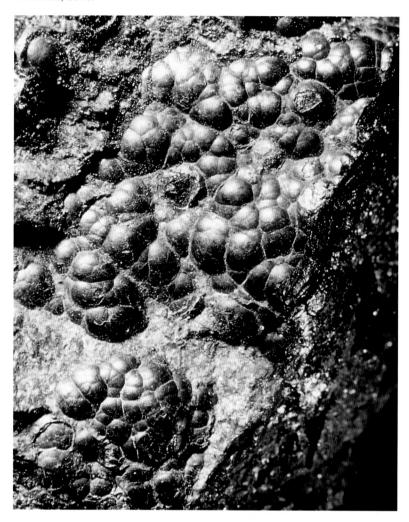

X-Ray Autoradiographs of Pitchblende.

Right: Pitchblende ore was the source of uranium for the first atom bomb. Placed directly on photographic film, the ore exposed it where radioactivity was the most intense. Goro Studio, New York, 1946.

Site of First Atom Bomb Blast.

Following page: As seen from the air, the remains of the tower on which the detonation took place sit amid a dark area where the heat of the blast fused the desert sand into glass. Alamogordo, New Mexico, 1945.

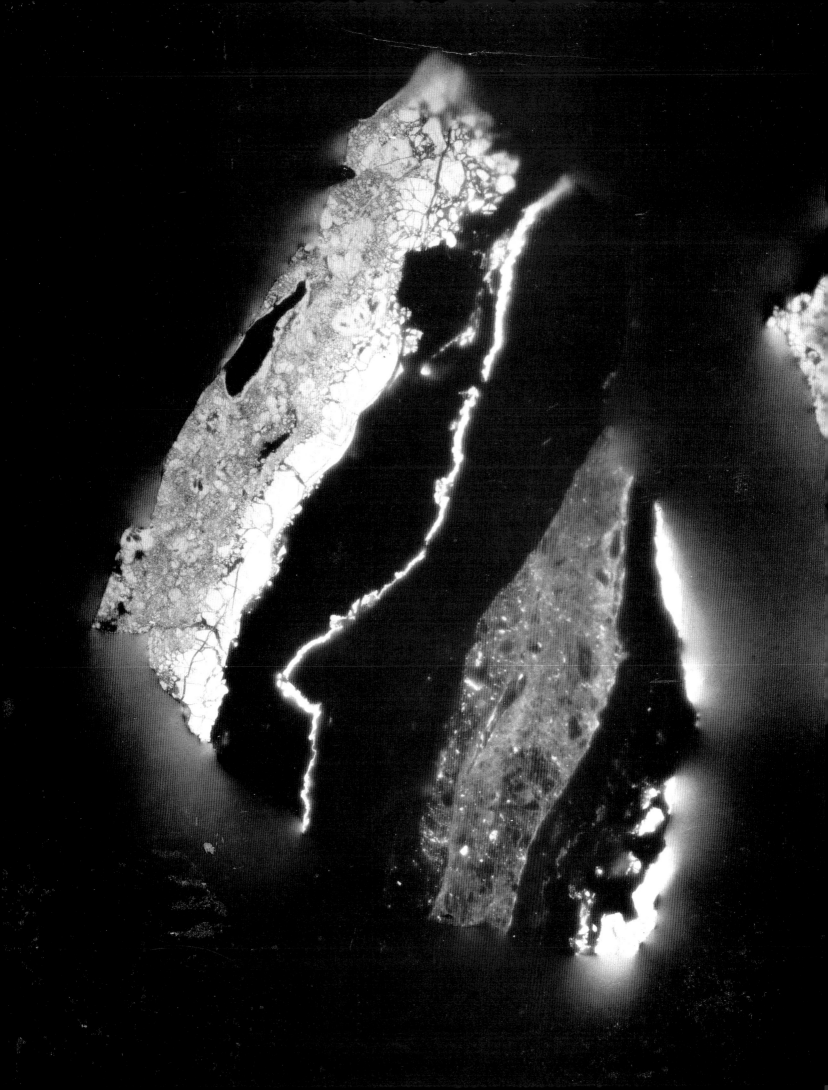

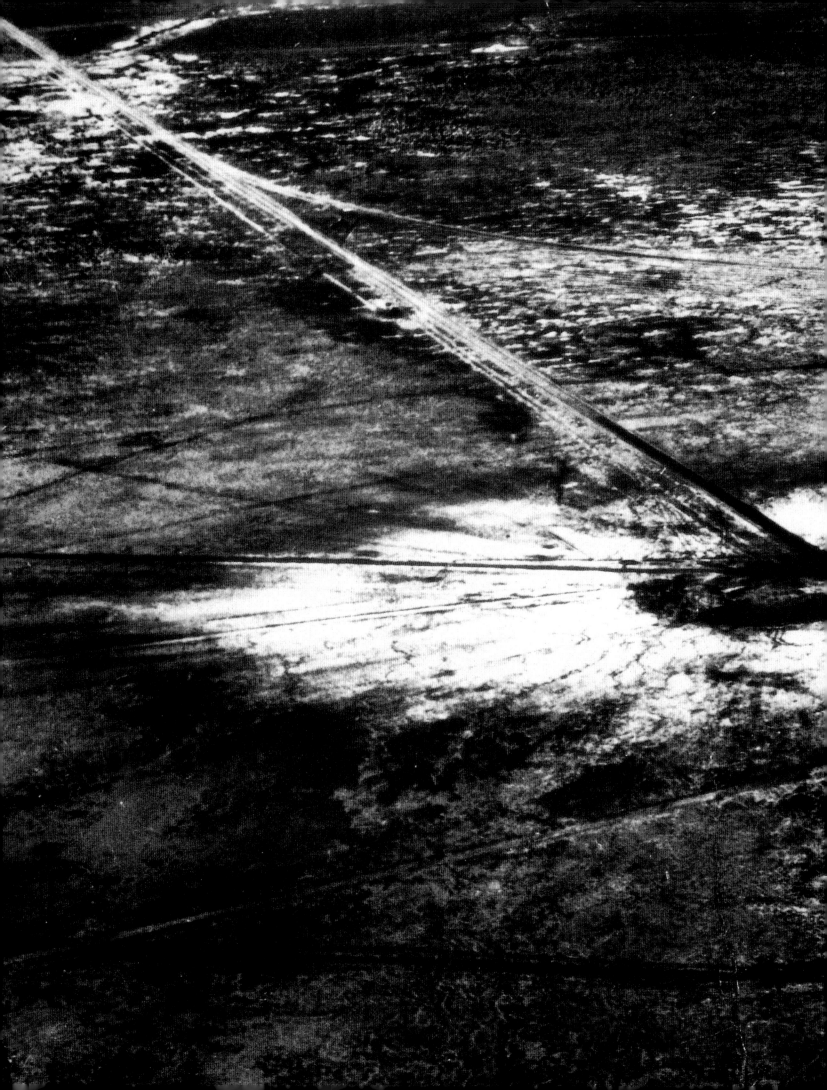

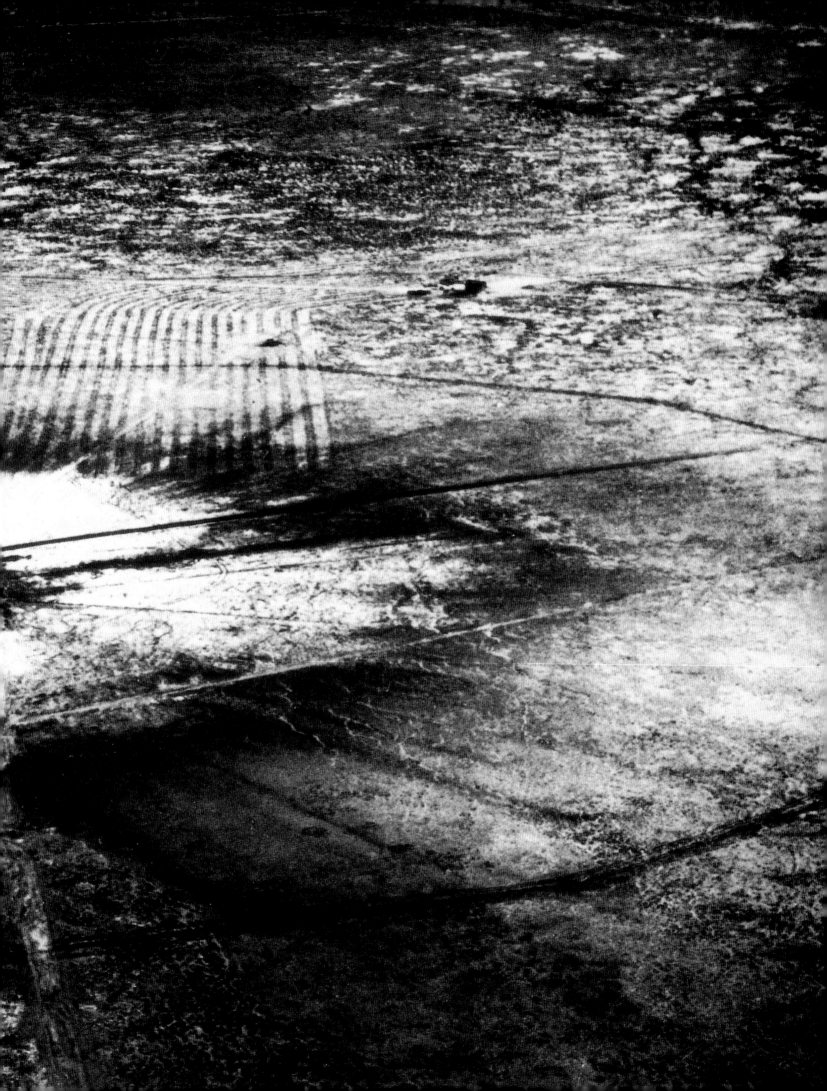

Desert Sand Turned to Glass by Atom Bomb.

Quartz sand at the Alamogordo test site was melted by the explosion's heat, and formed little puddles of glass over the ground surrounding the carbonized stumps of desert plants. Alamogordo, New Mexico, 1945.

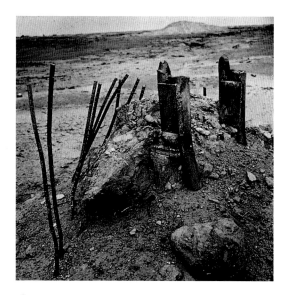

Ground Zero.

The blackened, twisted steel remains of the support tower at ground zero, seen from the ground shortly after the first atom bomb explosion. Alamogordo, New Mexico, 1945.

Oppenheimer and Grove at Ground Zero in Linen Boots.

Right: Dr. Robert Oppenheimer and General Leslie Grove, the military commander of the Manhattan Project, inspect ground zero, wearing only linen wraps around their shoes. To send people onto ground zero so soon after a nuclear blast without protection from radiation would be considered criminal negligence today. Incredibly, no effort was made to monitor the biological effect of radiation in the first bomb blast. Oppenheimer, Grove, and Goro all died of various forms of cancer. Alamogordo, New Mexico, 1945.

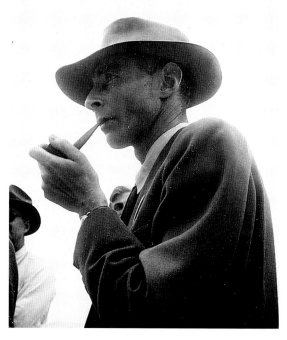

Above: Dr. Robert Oppenheimer, the leader of the scientific team that built the first atom bomb, smoking his pipe at ground zero. 1945.

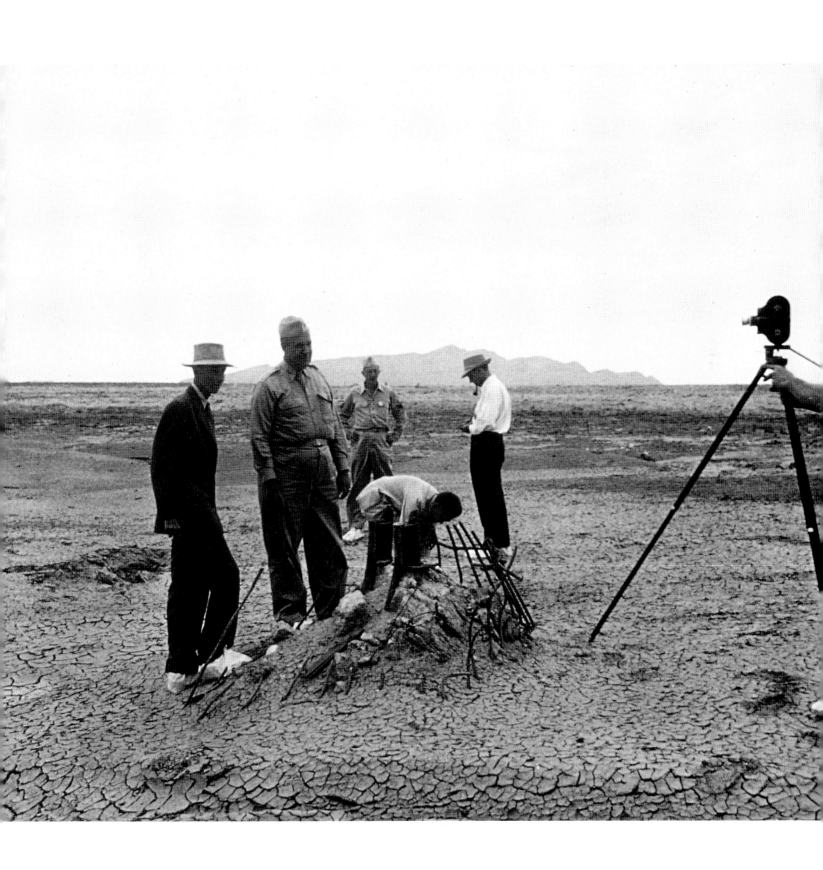

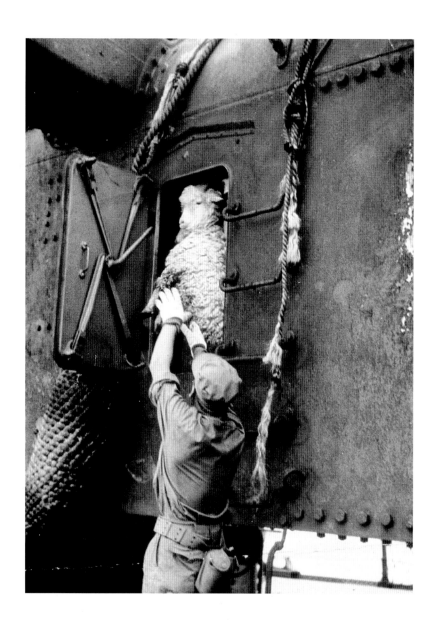

Sacrificial Lamb Readied for Nuclear Exposure.

In 1946, after the nuclear bombs were detonated at Hiroshima and Nagasaki, the first scientific experiments on the biological effect of exposure to nuclear radiation took place. This lamb was strapped into place for exposure to an experimental bomb blast at Bikini Atoll, in the middle of the Pacific. Bikini Atoll, 1946.

Nuclear Rat's Paw.

Exposed to fallout from the atom bomb at Bikini Atoll, this white rat developed a grossly misshapen paw. Brookhaven, New York, 1946.

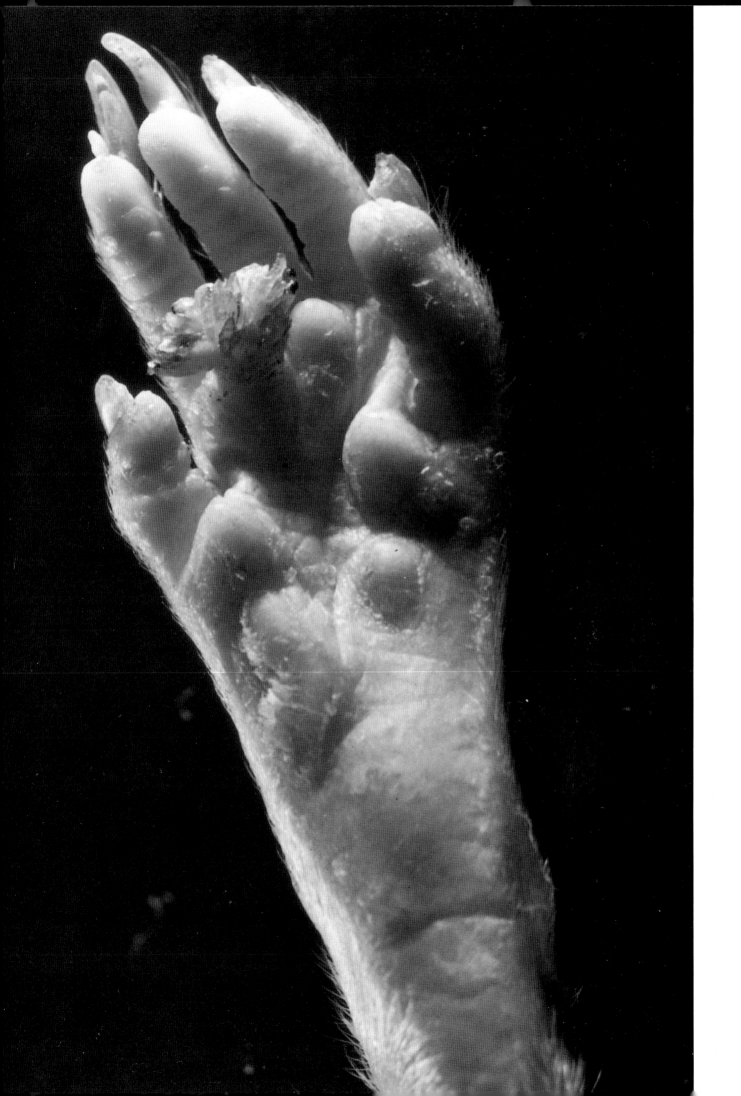

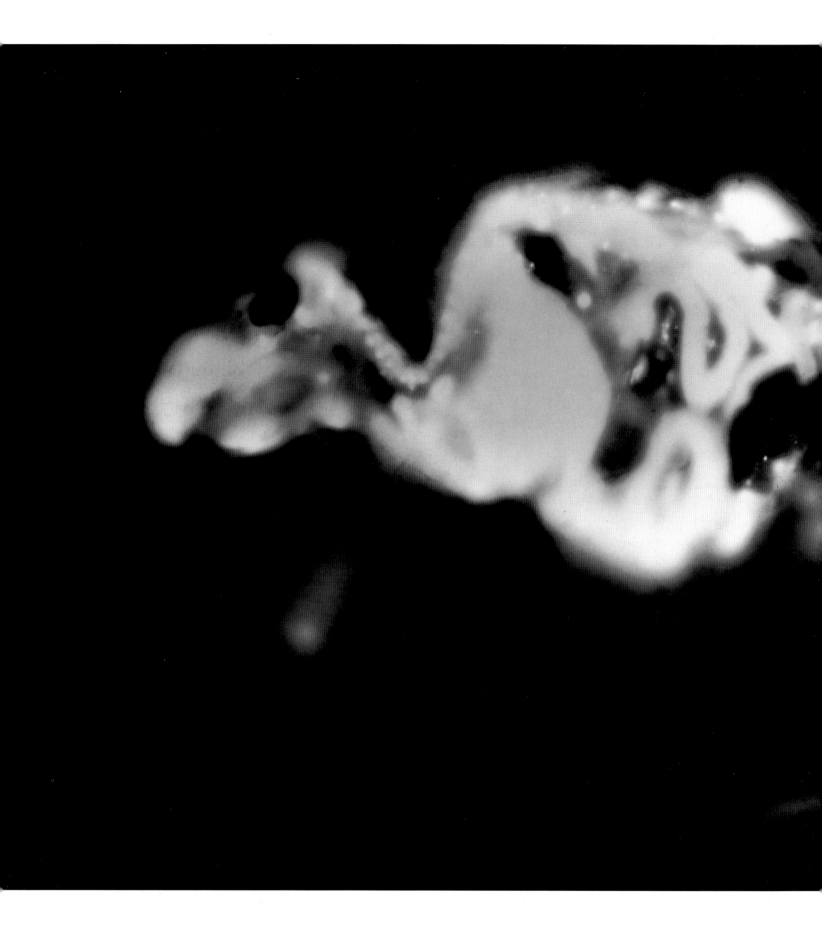

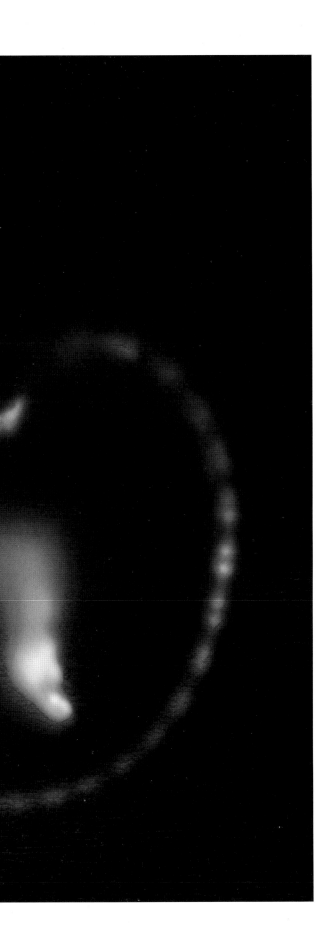

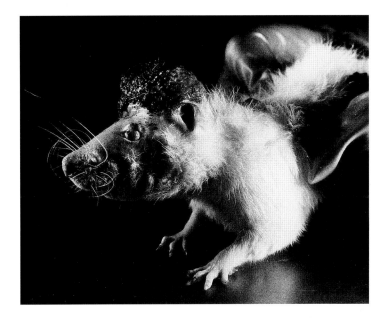

Nuclear Rat's Head.
Nuclear radiation exposure at Bikini Atoll caused this rat
to grow large tumors. Brookhaven, New York, 1946.

Nuclear Rat's Autoradiogram.
Kept in a cage and exposed to fallout from the Bikini Atoll
bomb blast, this rat absorbed so much nuclear radiation
that its internal organs could directly expose a photo-
graphic plate beneath the sectioned animal, revealing the
distribution of radioactivity. Brookhaven, New York, 1946.

L-Dopa Crystals.

Crystals of L-Dopa seen in polarized light. This compound is converted to dopamine, which
acts in the brain to reverse the symptoms of Parkinson's disease. L-Dopa specimen
courtesy of Department of Neurology, Columbia University. Goro Studio, New York, 1976.

MOLECULES

Molecules are combinations of atoms held together by chemical bonds in patterns that reflect underlying symmetries in atomic structure. Molecules come in a vast array of sizes and geometries, which affect their chemical and physical properties. Molecules occur in a variety of states depending on physical conditions around them: packed into solid symmetrical arrays as in crystals, in solid random arrangements as in glasses, in random freely mixing volumes as in liquids, moving independently of each other as in gases, or highly charged and stripped of electrons as in plasmas.

Molecules in fluid states flow in astonishingly complex ways, from smooth laminar flow, through various wavelike states, to chaotic and irregular turbulence. These motions are usually visible only through exceptional lighting conditions, yet they play important roles in many fundamental physical and biological phenomena. In exceptional cases, uniform liquids can be made to generate rotating spiral waves.

Molecules at interfaces between physical states, such as bubble surfaces, have unusual properties because of surface tension forces. They adopt the lowest energy levels available to them, forming a variety of curved and straight surfaces subject to precise mathematical rules and illustrating fundamental aspects of geometry.

The colors in this beautiful polarized-light photograph reflect the optical activity of the L-Dopa crystals. They rotate a beam of light in one direction—in this case, to the left (hence laevo, or L-Dopa). The mirror image of this is dextro, or D-Dopa, which rotates light to the right. Pasteur, in his first great discovery as a young man, found that such rotations reflect asymmetries in the molecules themselves, the fact that they may be "left" or "right-handed." It was Pasteur's further insight that living processes do not make use of symmetrical molecules, but only asymmetrical ones, usually the L-form. The D-Dopa has no biological role, but L-Dopa is widely distributed in animal and plant tissues (some beans contain almost 10 percent by dry weight), and has a crucial role to play as a precursor of the major neurotransmitter dopamine, which transmits nerve impulses across neuronal junctions in the brains of all vertebrates.

If there is a deficiency of dopamine, these synapses cannot function, and the affected animals (or people) cannot move normally—they become motionless (parkinsonian), sometimes lethargic and depressed. Giving them L-Dopa, which their bodies can convert to dopamine, can restore them to virtual normality for a time. L-Dopa is crucial in maintaining a reasonable existence for millions of people with Parkinson's disease, and it was with L-Dopa that I "awakened" the post-encephalitic patients under my care, some of whom had been "frozen" for decades.

Oliver Sacks
Clinical Professor of Neurology
Albert Einstein College of Medicine

Salt Crystals.

Salt Crystals forming in the Great Salt Lake, Utah, 1939.

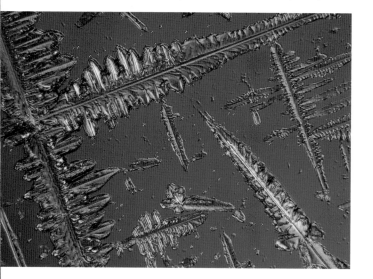

Chlorophyll Fluorescence.

A deep green solution of chlorophyll from spinach leaves (top) is illuminated by bluish ultraviolet light (bottom) and fluoresces bright red (middle). This photograph was taken in the laboratory of Dr. A. Lamme at Columbia University from chlorophyll extracted by Dr. Robert K. Trench. New York, 1974.

This image illustrates the most fundamental aspect of photosynthesis: capture of the radiant energy of sunlight by the green pigment chlorophyll and its transformation into chemical potential energy, represented by the red fluorescence. In the cell this energy is used for the synthesis of organic molecules.

Robert K. Trench
Department of Biology
University of California,
Santa Barbara

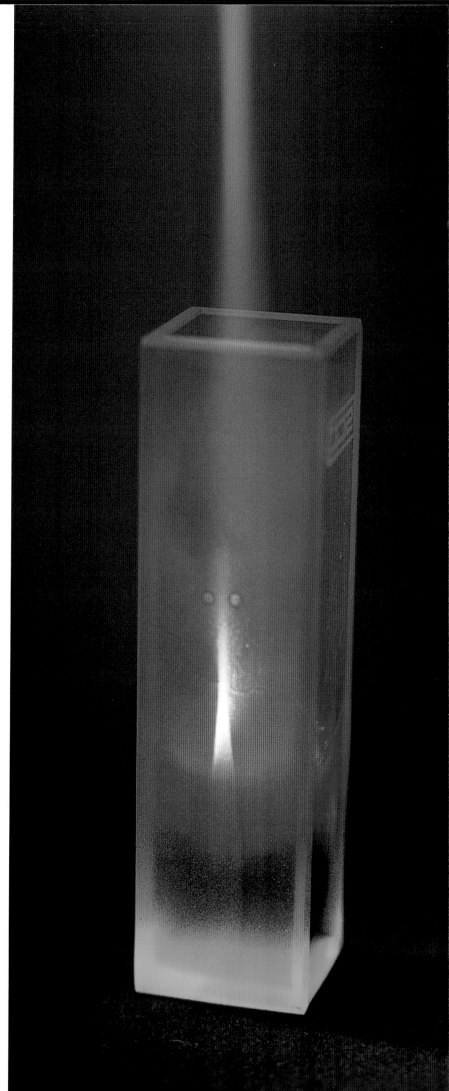

In metals, electrons are shared by all atoms, giving rise to an extremely mobile but bound electron fluid that responds to electric and magnetic fields. This allows near perfect reflection of visible light, collection of radio energy, and conduction of electrical currents. Insulators are materials that inhibit internal flow of electrons. From conductors, insulators, and semiconductors, composite materials can be constructed that have an extraordinary range of behavior, providing the base for modern electronics: integrated circuits, computers, and optical information processing. Each molecule interacts with light in a unique way. Most wavelengths do not affect them, but certain pure colors are readily absorbed. Each molecule has its own characteristic wavelengths. Their atoms respond to light absorption by altering their rates of vibration and rotation, stretching and twisting the chemical bonds between them. If strong enough, light may cause molecules to break apart into smaller molecules, adopt different configurations, attach to other molecules, or emit light of longer wavelength as fluorescence.

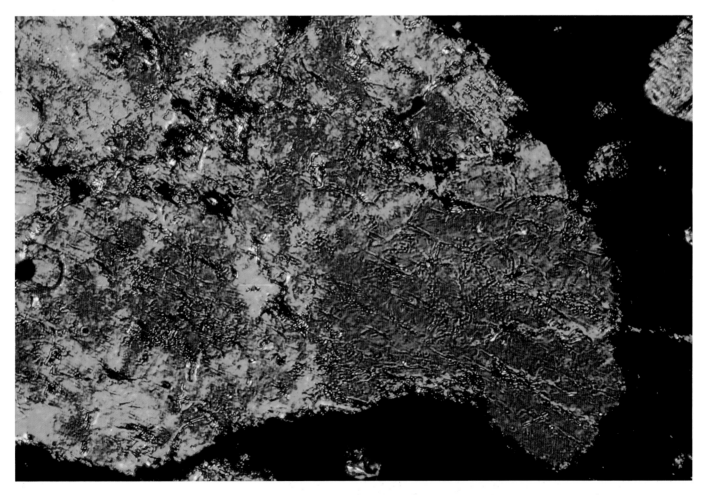

Shock Wave Glass from the Moon.
This moon rock sample has had its component crystals turned into featureless glass after being shattered by shock waves from the impact of ancient meteorites with the primordial moon. Houston, Texas, 1969.

Moon Rocks.

Thin sections of moon rocks viewed in a petrographic microscope under polarized light. The colors reveal types of minerals and their orientations. These rocks were brought back from the moon by Apollo astronauts and sectioned at the NASA Space Center. Houston, Texas, 1969.

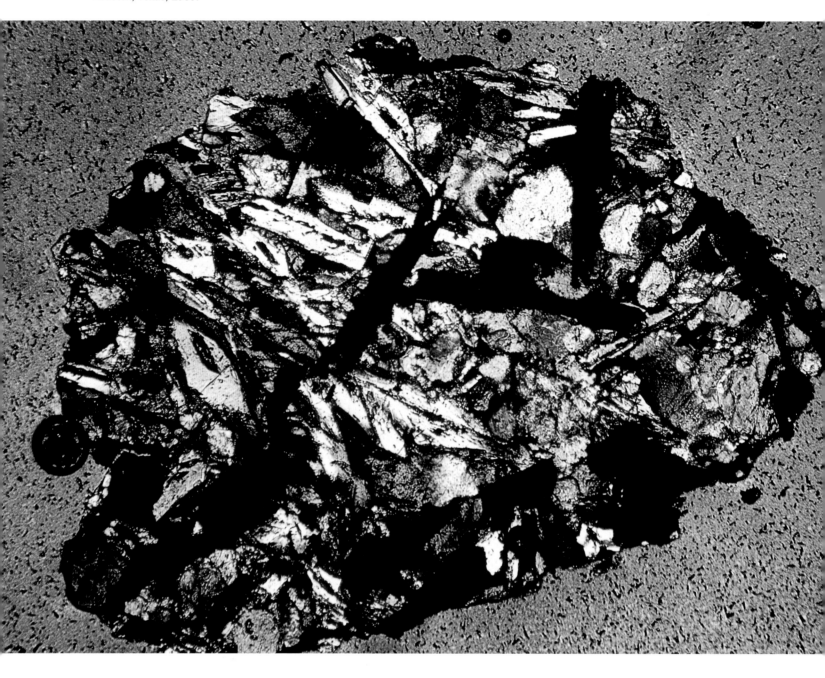

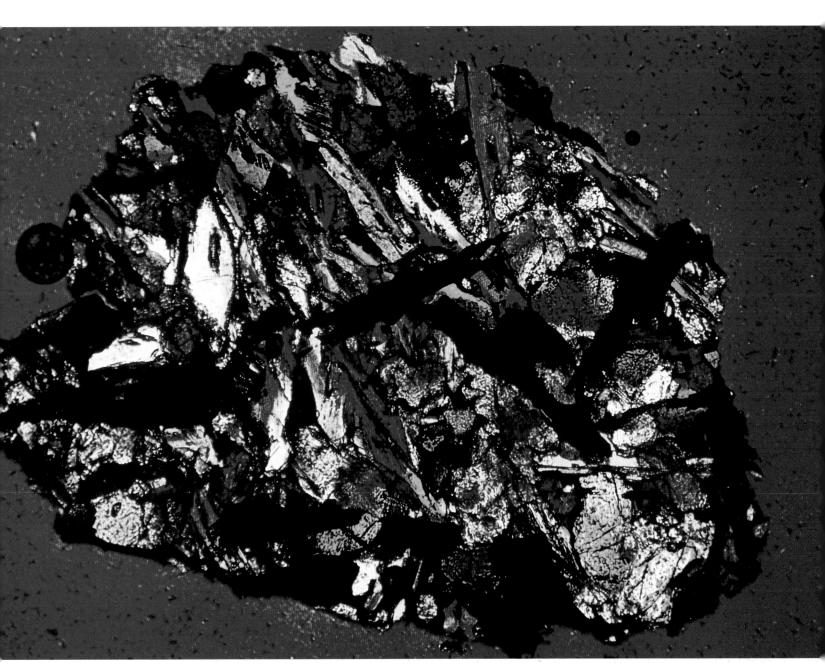

Electronic Chips.

Early integrated semiconductor chips, Goro Studio, New York.

A. Electronic chip terminals, 1977.

B. Integrated computer chip. Texas Instruments, 1977.

C. Connections in an early integrated circuit. California
 Institute of Technology, 1971.

D. Metal oxide doped field-effect transistor widely used in
 computer memory and switching chips. IBM, 1973.

E. Logic circuits. Stanford University, 1977.

A.

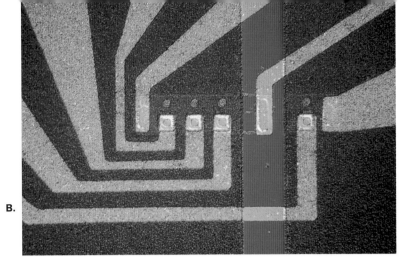

B.

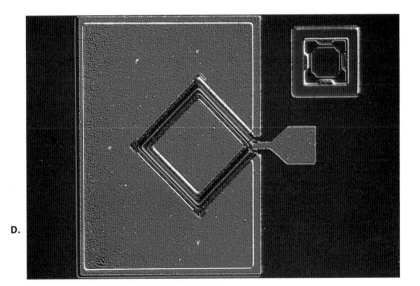

C.

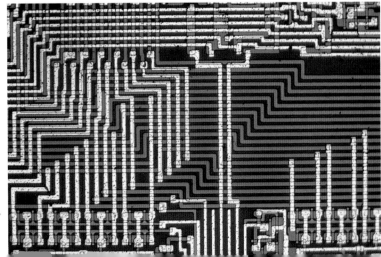

D.

E.

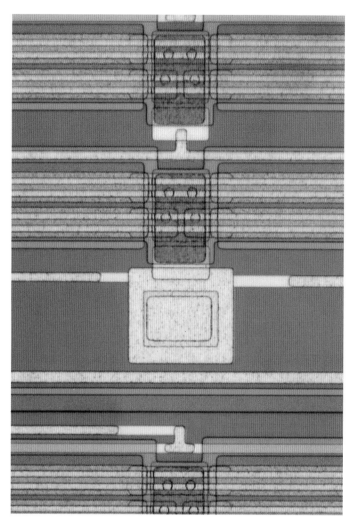

Josephson Superconducting Junctions.
Polarizing light micrographs of Josephson junctions, which become superconducting devices when cooled to low temperatures. This quantum tunneling effect is expected to form the basis for the next generation of ultrasmall, ultrahigh-speed computers. Goro Studio, New York, 1980.

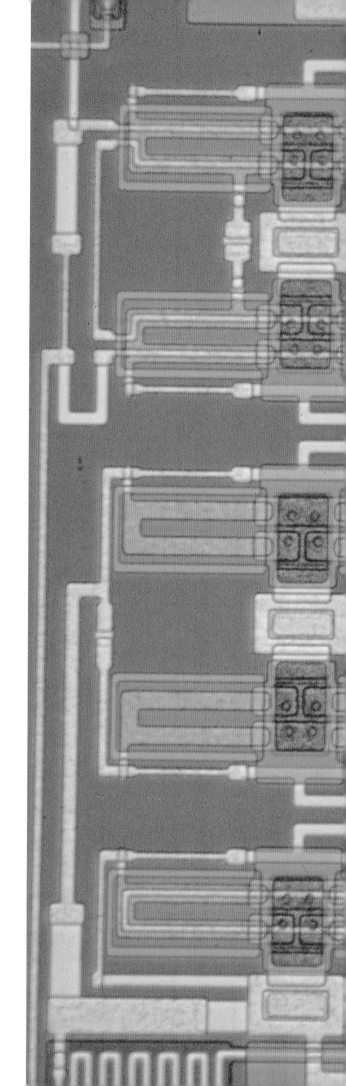

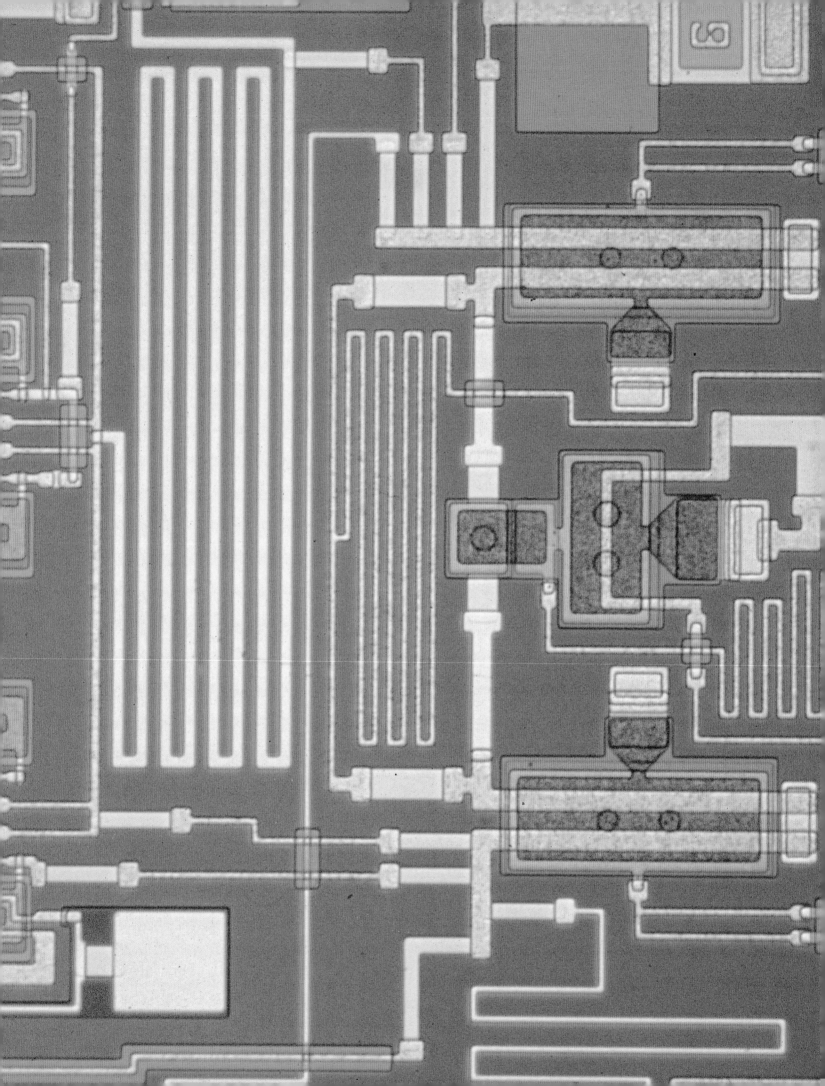

Glass Spheres from the Moon.

Left and below: A striking component of lunar dust are the tiny spheres formed when the spray of molten rock from meteorite impact solidifies into glass in space before falling back to the moon's surface. These are viewed in reflected and transmitted light. Houston, Texas, 1969.

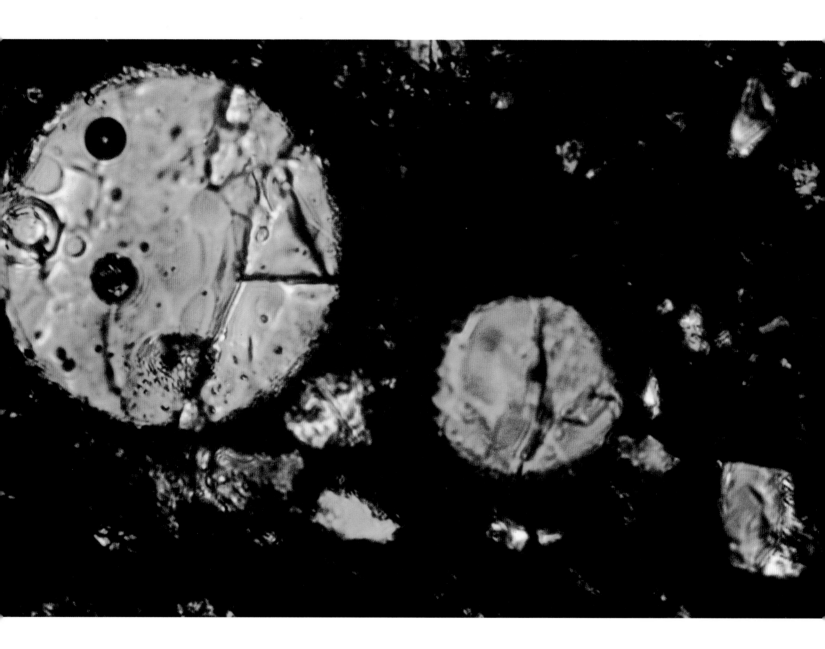

Glassy and Crystalline Silicon.

Left: The surface texture of sheared specimens of ordered crystalline silicon for semiconductors is very different from that of glassy amorphous silicon. *Right*: Noncrystalline silicon, developed by Dr. Stanford Ovshinsky, may have important applications in solar cells and integrated circuits. Michigan, 1969.

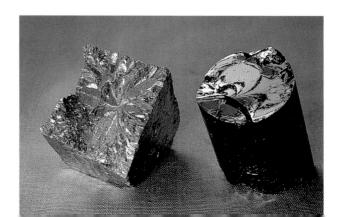

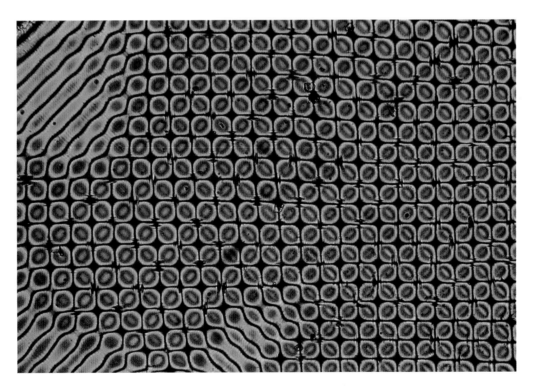

Ferroelectric Domains in Computer Memory.
Brightly colored domains show common electrical orientation of molecules in the cores of early computer ferrite memory elements. Bell Labs, New Jersey.

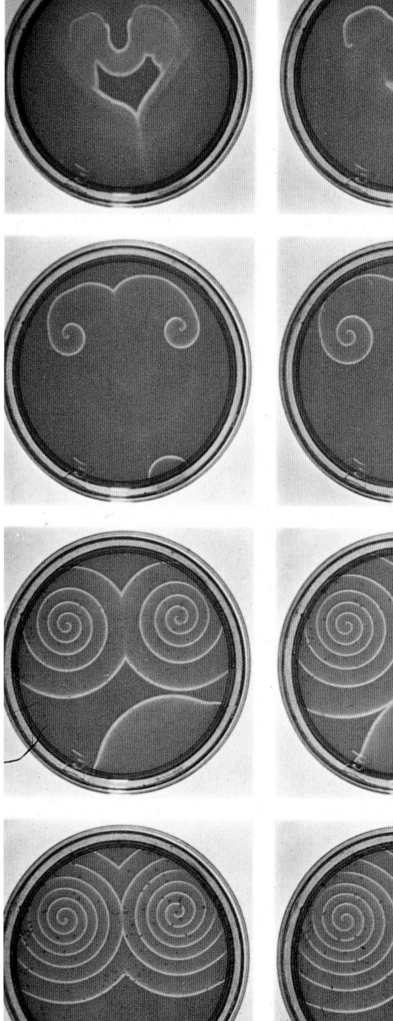

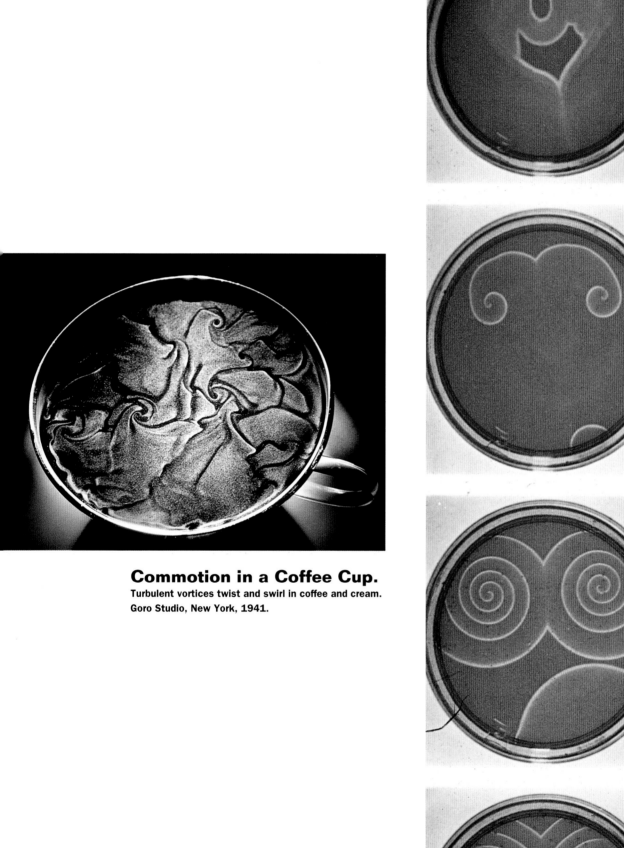

Commotion in a Coffee Cup.
Turbulent vortices twist and swirl in coffee and cream.
Goro Studio, New York, 1941.

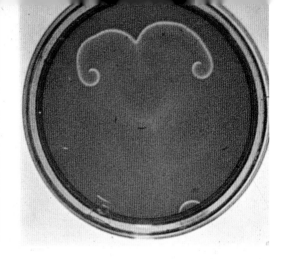

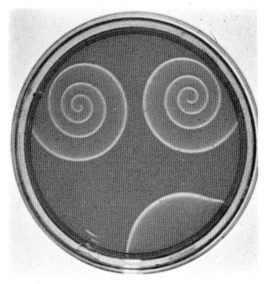

Rotating Reactions.
This time series shows the development of spiral, rotating, colored waves in a glass dish, formed by the Belousov-Zhabotinskii reaction. Taken in the laboratory of Dr. Arthur Winfree in Bloomington, Indiana, 1974.

In 1970 a chemical experiment was attempted to demonstrate the impossibility of spiral waves in a perfectly continuous medium. The result, shown here, instead demonstrated an unexpected way that chemical reactions can organize themselves in space and time: A tiny disk of stably self-organizing structure is created, called a rotor, which spins at a fixed speed while emitting a wave of chemical change. This photo became a symbol of diverse revolutionary developments in chemistry, mathematics, physics, optics, physiology, and medicine during recent decades. It thus became an icon of spatially ordered dynamics in general.

Arthur Winfree
*Department of Ecology and
Evolutionary Biology
University of Arizona*

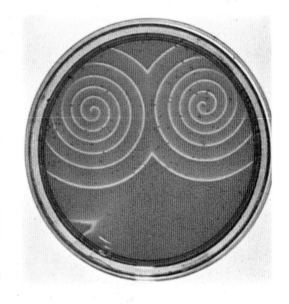

In my monograph, From Being to Becoming: Time and Complexity in the Physical Sciences, *I reproduced Mr. Goro's beautiful photographs of the Belousov-Zhabotinsky reaction and, more precisely, of the chemical scroll waves that he photographed in Arthur Winfree's laboratory. These photographs illustrate one of the most unexpected aspects of the behavior of matter, which has been discovered quite recently. The appearance of these chemical scroll waves shows that non-equilibrium (here, chemical activity) leads to coherence, to long-range correlations that are responsible for the beautiful patterns photographed by Mr. Goro. Traditional wisdom taught us that order was associated with equilibrium, disorder with non-equilibrium. We see now that this is not true, that non-equilibrium can also generate order and coherence. This discovery is at the very basis of concepts such as self-organiation and "dissipative structures," which play a central role in the world around us. Mr. Goro's photographs certainly have helped attract attention to the intrinsic beauty of non-equilibrium patterns and, therefore, also to the present shifting of our interest from the classical equilibrium paradigms to the present paradigms centered around non-equilibrium forces.*

Ilya Prigogine
*Ashbel Smith Regents Professor
University of Texas, Austin*

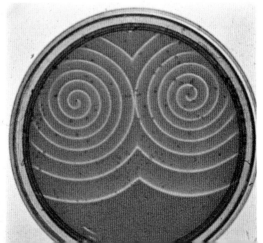

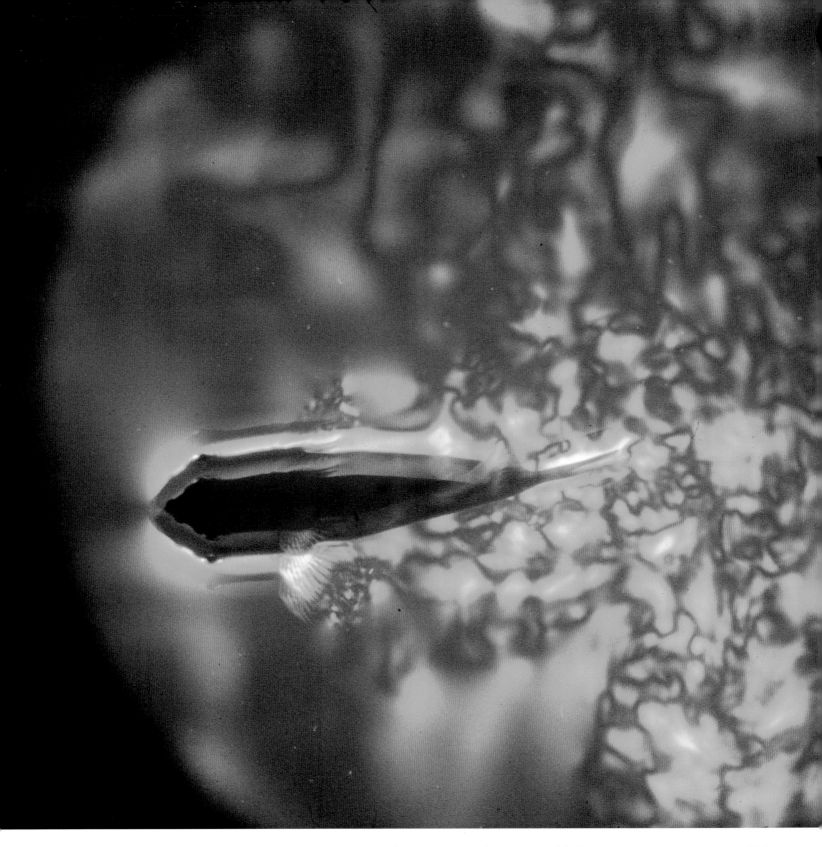

I clearly remember my first encounter with the name Goro as a kid in Switzerland. My father brought home an issue of Life magazine from his first trip to the United States after World War II. One photo fascinated me, but what foremost stuck in my mind was the name Fritz Goro. From that moment I searched every magazine for the Goro name. What I found were photographs visualizing concepts of science; each picture narrowed my aim and enlarged my horizons. In 1978 I gave a talk at a marine science conference at Stonybrook, New York. My findings were contained in a silent movie utilizing high-speed cinematography showing the feeding behavior of microscopic marine animals. I had to speak in synchrony. My voice almost gave way when I was told that in the audience was Fritz, the master of amalgamating art and science.

Rudolf Strickler
Center for Great Lakes Studies
University of Wisconsin

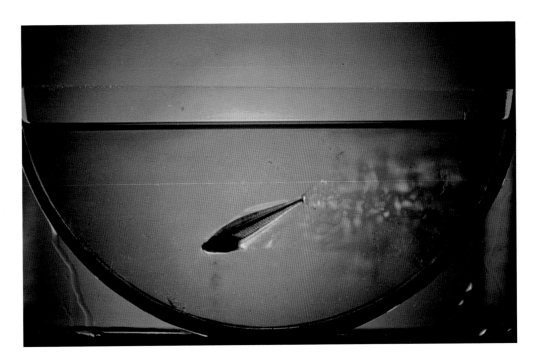

Fish Tracked by the Tobacco Mosaic Virus.

The variations in light seen in a solution of Tobacco Mosaic Virus illustrate the flow of fluid behind the fish, allowing its wake to be clearly visualized. *Top*: Tobacco Mosaic Virus growth causes round spots to develop on tobacco leaves. Goro Studio, New York, 1941.

Bubbles are very tricky to photograph because they are transparent and evaporate under bright light; careful background choice and light conditions are required. One bubble photograph actually shows Fritz Goro's reflection. At first it is hardly noticeable, but it is very clear once you discover it. With a single exception, these are the best bubble pictures I know.

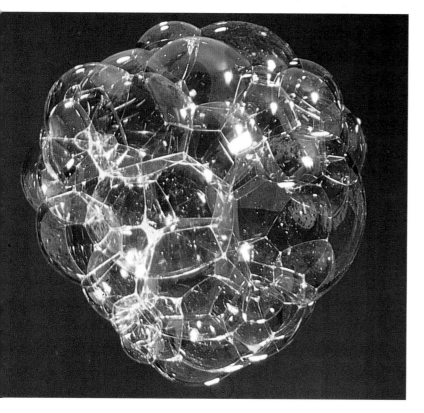

Bubble Mass.

Left: A mass of bubbles in free fall shows the geometry of the bubble surfaces free from constraining surfaces. Goro Studio, New York, 1976.

Bubble Geometry.

This selection of shapes formed by soap bubbles shows the geometry of soap films where they join. Certain mathematical rules determine the angles at which they intersect. The soap film in the lower figure has two free ends and does not span a topological "hole." *Top*: This setup would not be possible if the frame were much thinner. Soap film geometry photographs required careful control over lighting and background to maximize the reflection of bubble surfaces. Goro Studio, New York, 1976.

The bubble cluster in free fall beautifully illustrates the geometry that results from the principle of area minimization. The bubble in the S-shaped frame shows a soap film that many mathematicians would have thought impossible because the bounding wire has free ends. Such soap films have been the subject of several recent mathematics papers.

Frederick J. Almgren, Jr.
Professor of Mathematics
Princeton University

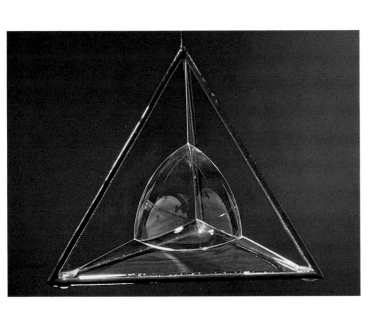
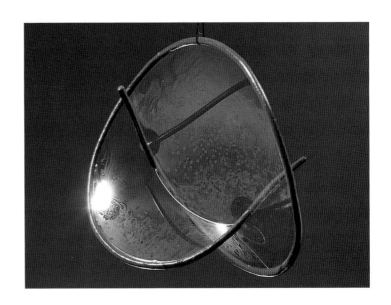

CELLS AND TISSUES

Life is based on the cell, a sac of water containing select molecules separated from the outside world by a membrane. The size, shape, and appearance of cells vary enormously, yet they share a common biochemical control system based on information encoded in molecules called nucleic acids. The central unit, the long DNA helix, contains all the encoded information needed by the cell. It is read off in short sections by special molecules that make RNA copies, which are then carried to the cell's factories, which read the RNA instructions and manufacture proteins

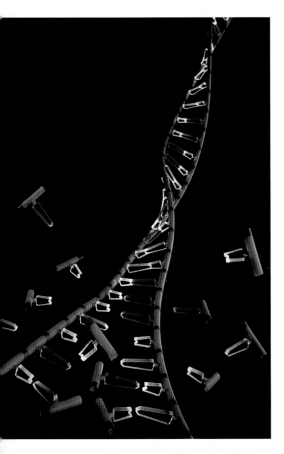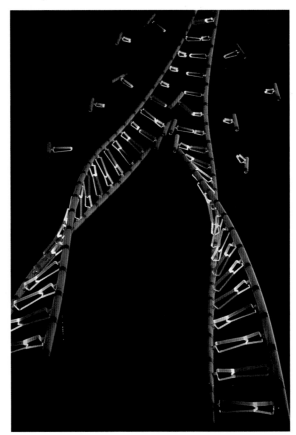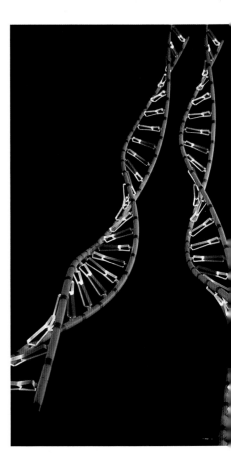

and enzymes. These build the cell structure and synthesize or take up all the other molecules required by the cell. Those molecules include salts, sugars, waxes, fats, and oils, some dissolved in the watery cell interior, others avoiding water by clumping into droplets, membranes, and other ordered internal structures.

Cells utilize the raw materials around them to manufacture all their own needs for growth and reproduction. This is done in the simplest cells, like bacteria, by copying the DNA and splitting the cell into two, each with identical DNA. In more advanced cells DNA is packaged inside a special structure, the cell nucleus. These cells may grow either through simple duplication or through the more complex process of sexual reproduction, in which parent cells combine their DNA, producing offspring with hybrid genetic characteristics.

DNA Replication.

To illustrate the mechanism of genetic coding and information transfer, Goro and his assistant, Bob Campbell, built a twenty-foot model of a replicating DNA molecule. As the original double helix unwinds from below, each separated helix splices itself into a complementary helix so that each half strand reconstitutes the original whole. Goro Studio, New York, 1963.

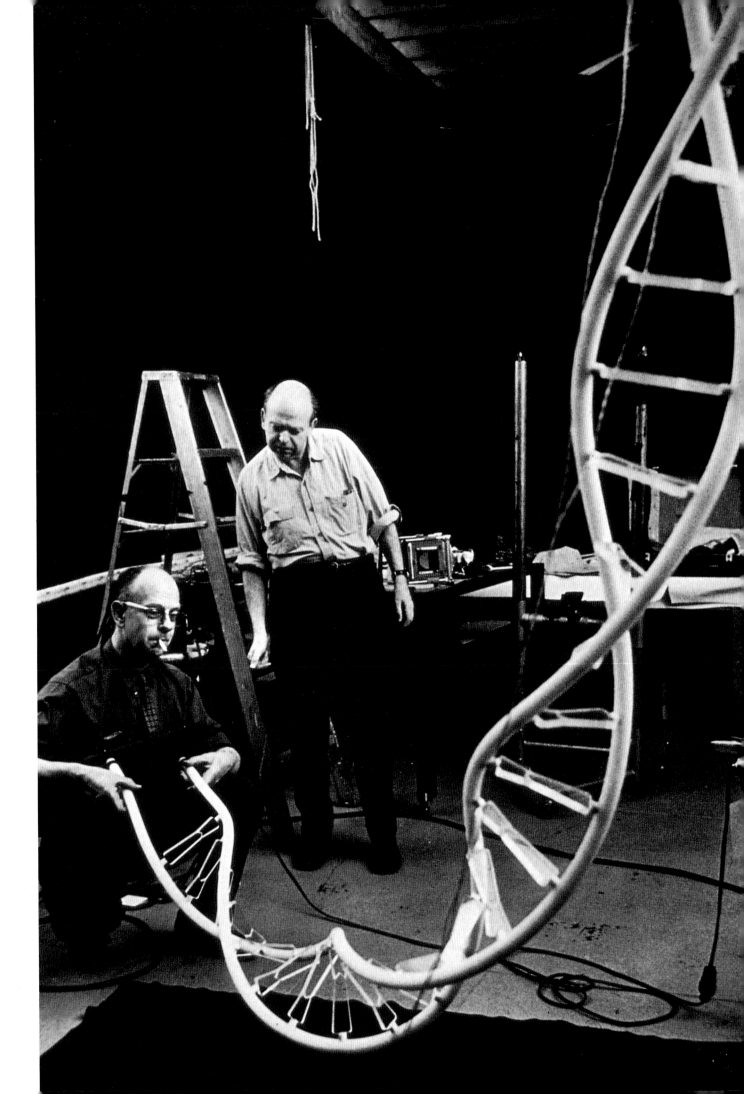

Over time, cells have become highly specialized, assuming a wide array of coverings and modes of life, and have gone from single-celled organisms to multicellular colonies. These range from simple aggregates to more complex ones whose cell layers are specialized into distinct tissues or organs with different functions. Although all cells in an organism contain the same DNA, each type of cell uses only specific portions of it. Changes in DNA, called mutations, occur due to radiation or chance errors in duplication. The cell may be unaffected, may be crippled, die, or go into uncontrolled growth, as in cancer tumors. In rare cases the cell may benefit by being better adapted to its environment.

Among the most remarkable cells are those that make up the nervous system, the brain, and the sensory organs such as the eyes. Through the course of evolutionary history, they have acquired DNA codes for making molecules that detect light, form images, transmit them to the brain, make decisions whether to approach or flee, and trigger the appropriate response from the muscles.

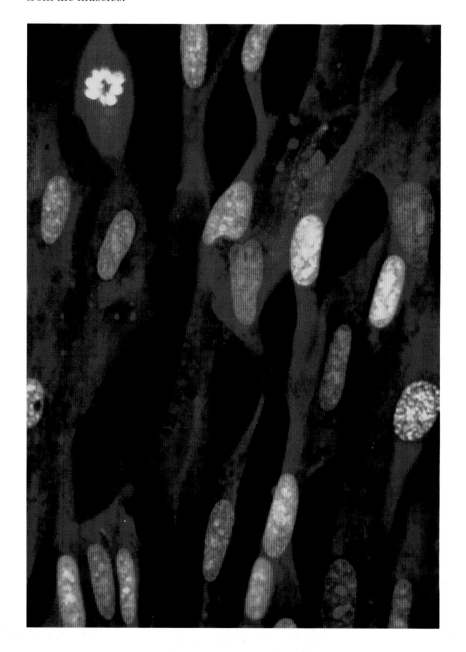

DNA Fluorescence.

DNA in lung tissue cells fluoresces bright yellow and green, while RNA fluoresces orange and red. Goro Studio, New York, 1963.

Artificially Fertilized Mouse Eggs.

A mouse egg, artificially fertilized in a glass dish in the laboratory of Dr. Yu-Chih Hsu at Johns Hopkins University Medical School, changes shape as it begins to develop. Baltimore, Maryland, 1979.

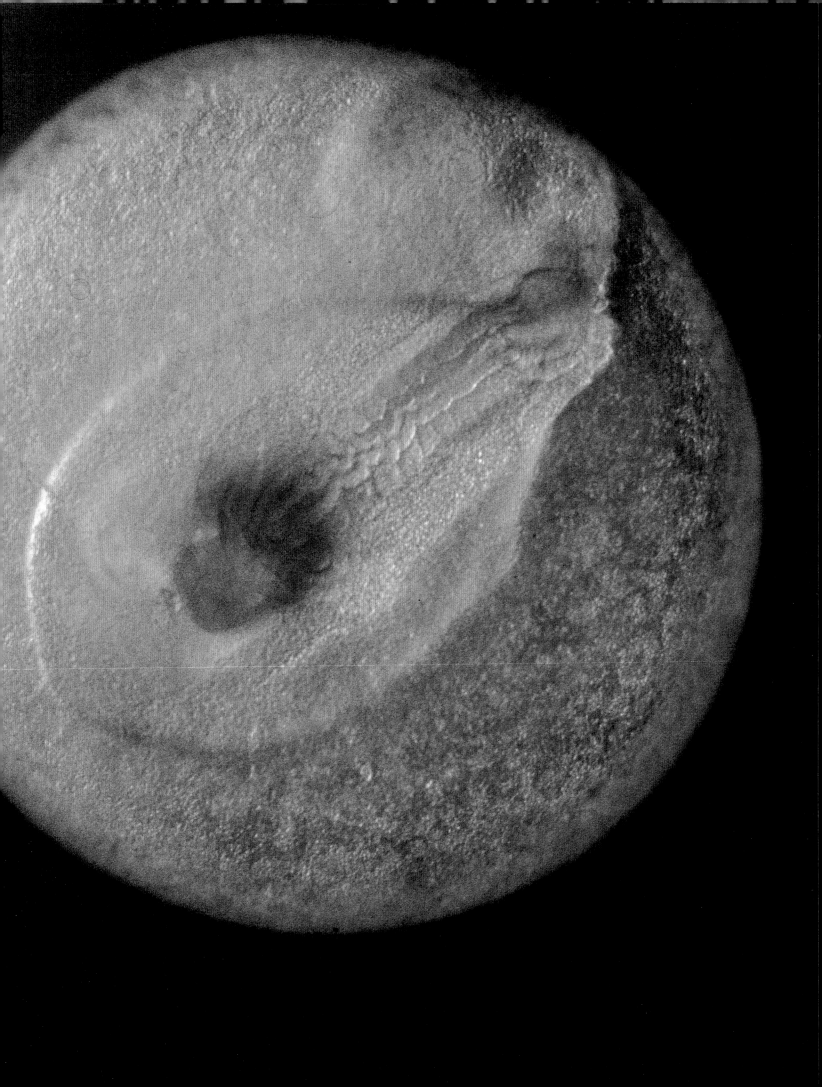

Artificial Fertilization.
Dr. Yu-Chih Hsu preparing a sample for
artificial fertilization. Baltimore,
Maryland, 1979.

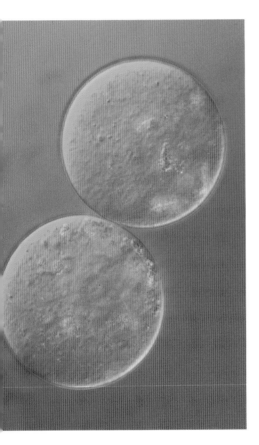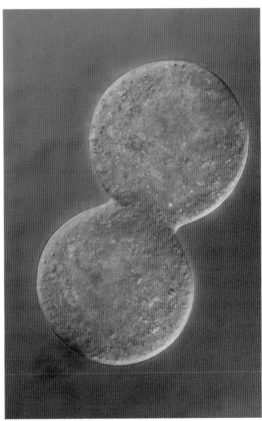

Cell Fusion.

Two mouse eggs fuse together, joining their genetic information into a single hybrid in experiments on genetic manipulation in the laboratory of Dr. Pierre Soupart at Vanderbilt University. Vanderbilt, Tennessee, 1979.

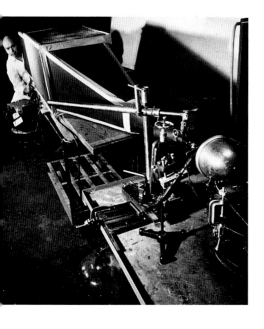

Blood Circulation Setup.
These photographs show the special camera with a one-hundred-inch focal length built by Fritz Goro to illustrate circulation of blood through veins in the skin of a living frog. Lab of Dr. Melvin Knisely, Chicago, Illinois.

Blood Circulation, from Life to Death.
Blood flow ceases and fine blood vessels collapse immediately upon the death of a frog. Chicago, Illinois, 1945.

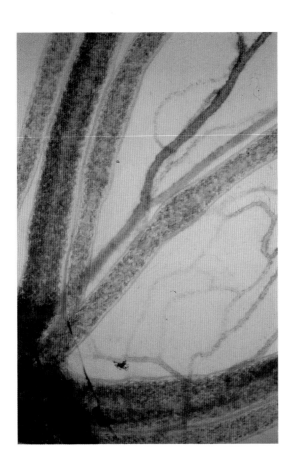 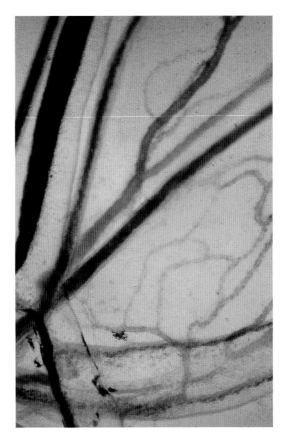

White Blood Cells Clump Around an Invading Cell.

This photograph, taken with a Nomarski Interference Microscope, shows the body's defense system in action and was made for the Squibb Chemical Corporation, New Jersey. Goro Studio, New York, 1974.

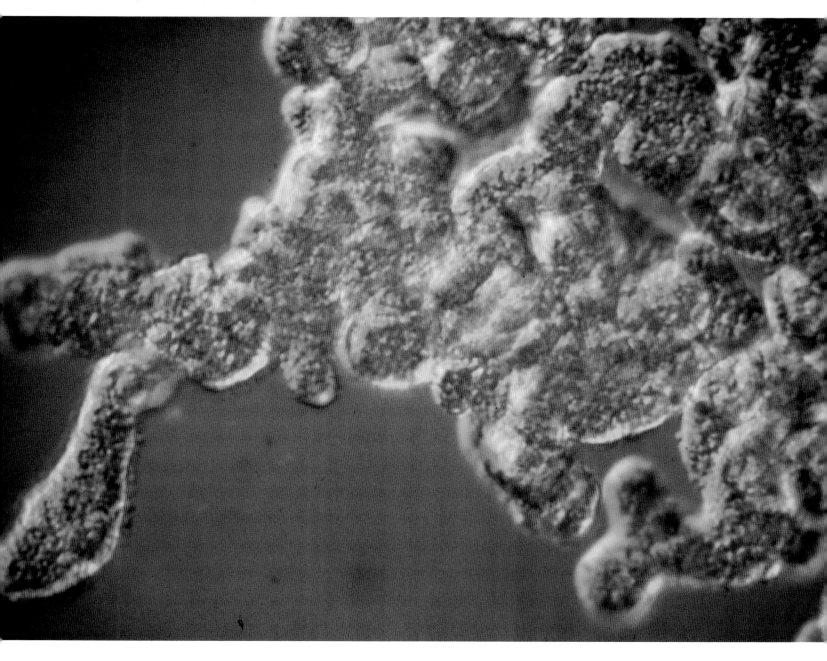

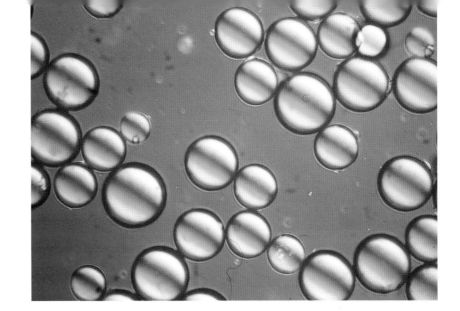

Fat Cells in an Obese Rat.
Fat cells extracted from a rat become spherical due to surface tension. 1976.

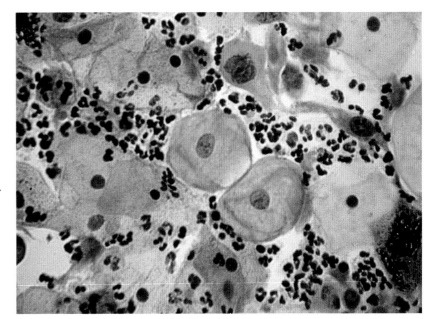

Normal and Cancerous Cells.
Cancerous cells in this Pap smear from Northern Westchester Hospital, New York, are much larger than their normal counterparts. Goro Studio, New York, 1976.

Cartilage of Rat's Knee.
Histological stains bring out the different cell types in stunning color. Goro Studio, New York, 1976.

Eye Damage from Glaucoma.

Seen in a thin section, damage due to glaucoma in the central portion of the eye, which normally has the sharpest visual acuity. Specimen courtesy of the Harkness Eye Institute, New York. Goro Studio, New York, 1976.

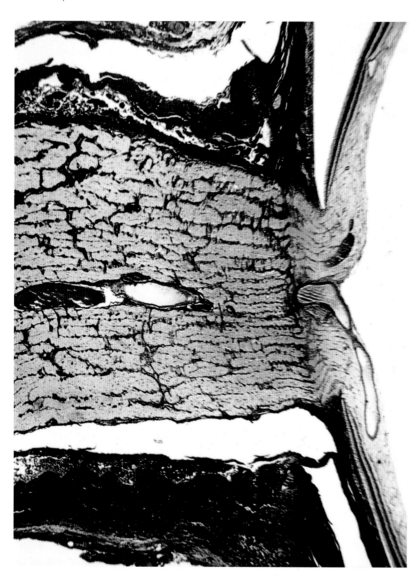

Detached Retina.

This slide, prepared by Margaret Cubberly, shows the retina detaching from the back surface of the eye, which is a common ophthalmological problem. Goro Studio, New York, 1976.

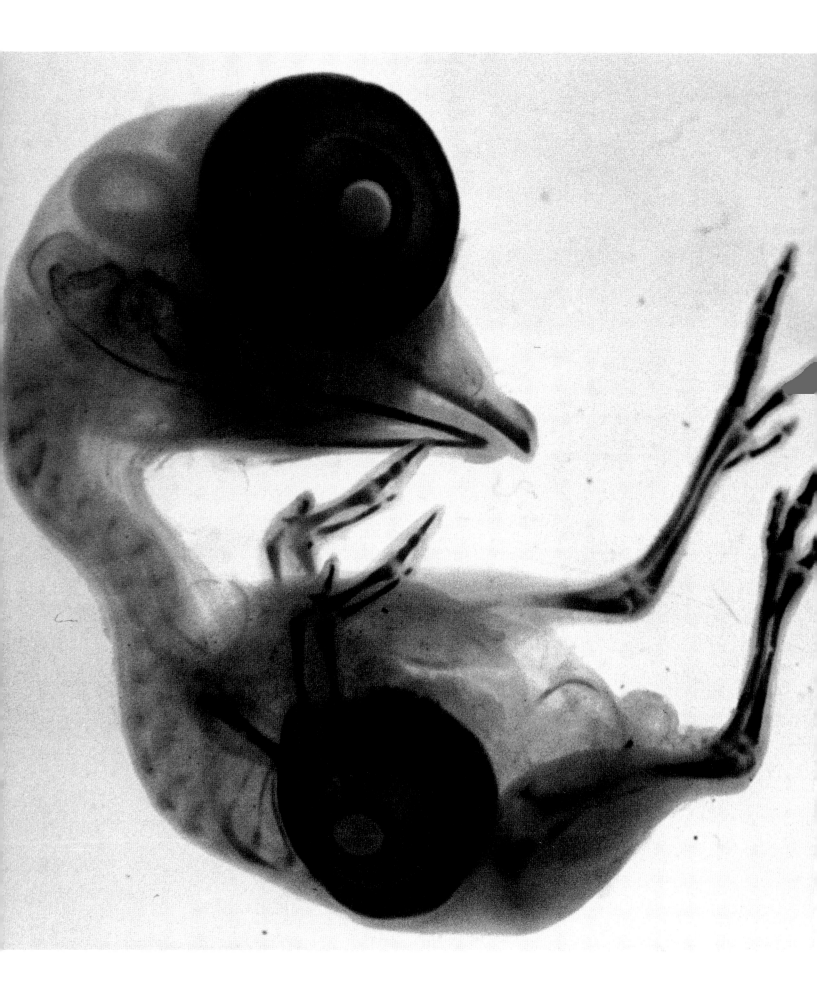

Early Organ Transplant.

In one of the earliest experimental organ transplants Dr. Victor Hamburger of the University of St. Louis transplanted the eye of a chick embryo. This success led to the modern era of human organ transplants. St. Louis, Missouri, 1937.

Whenever Fritz visited my laboratory we would talk for a while about the new experiment he was photographing and the problems in rendering its essence on film. He had been a well-known caricaturist before coming to the States and brought that talent into the still photography of natural science. Form was to direct the image rather than the other way around, in the way a good caricature of someone is more like him than any snapshot. This is a wonderful and difficult art, to make the photograph of something appear as characteristic of the thing and as recognizable as a good caricature of it. Listening to how he mused about the problem at hand, I realized that to him, optics and light were as brushes and pigments to a painter, highly manipulable tools by which to reveal the nature of the subject, not merely the appearance. Of course, then he would go on to his lively and penetrating reminiscences of people and places, evoking a nostalgia in his listeners for a past they had never experienced. At any rate, this photograph of Professor Hamburger's transplant is particularly good in showing that the eye is not simply a forced translocation but is becoming integrated with the host into a single chimera having a unity of its own. Here I am not talking of the experiment itself but of the feeling behind the experiment, the organic reorganization into a coherent, if odd, individual. It is a touch of high art, and far better than could ever be expected of a plain illustrative photograph, because it conveys much more than that an eye has been stuck where it shouldn't be. Viewing it again, I suddenly and acutely miss those occasional visits.

Jerome Y. Lettvin
Department of Biomedical Engineering
Rutgers University

Red Blood Cells in Capillary Vein.

Individual red blood cells circulating through capillary veins in a fold of the skin of a living salamander. Taken in the laboratory of Dr. Melvin Knisely, University of Chicago. Chicago, Illinois, 1945.

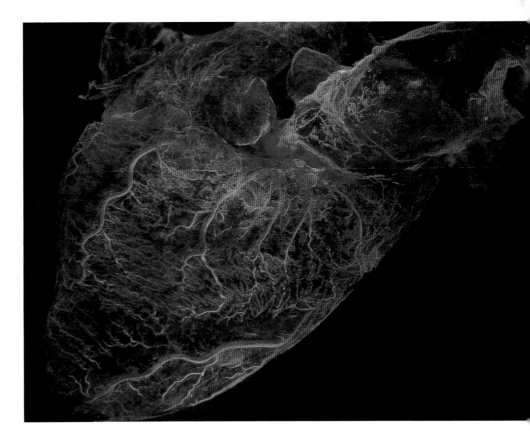

Human Heart Circulation.

This heart, from the collection of the Library of Medicine in New York City, has been treated to make the muscles transparent and to emphasize the system of blood circulation within the heart muscles. Goro Studio, New York, 1948.

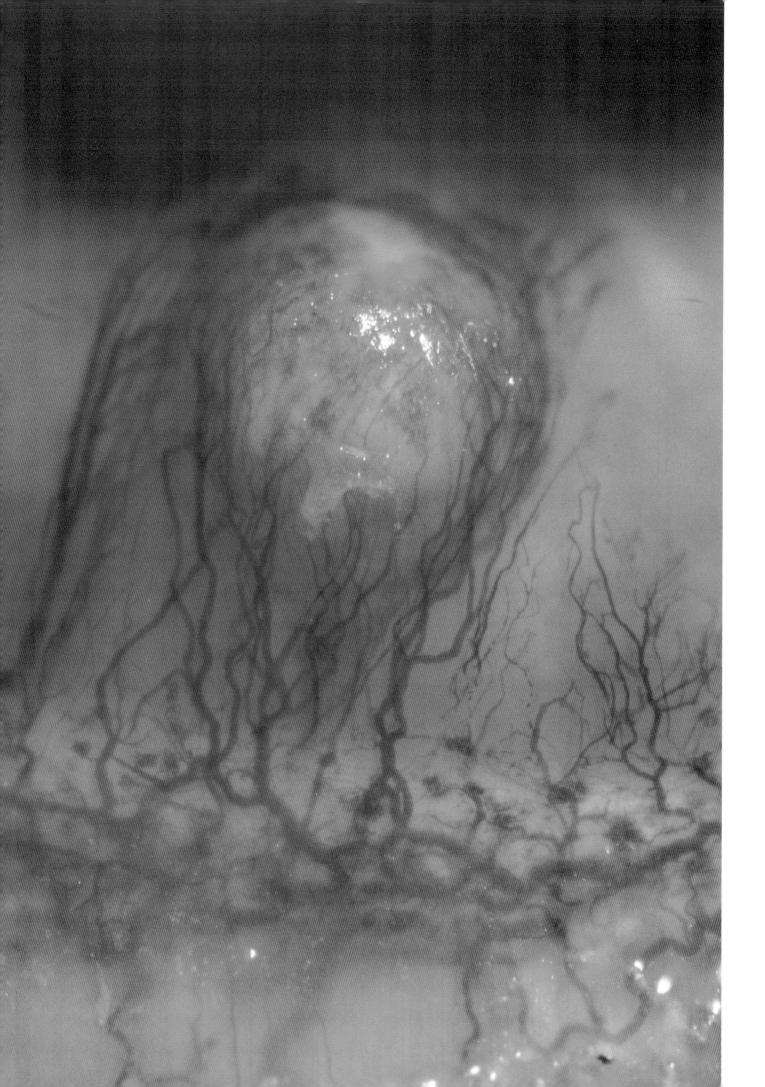

Cancerous Tumor Growth.

Left: A cancerous tumor in a rabbit's eye, studied by Dr. Judah Folkman in his laboratory at Harvard Medical School, has redirected the growth of a mass of vascular blood vessels toward itself to feed its rapid growth. Boston, Massachusetts. 1976.

Dendritic Neuron Network.

Complex pathways of nerve connections are seen in this section from human brain tissue. Goro Studio, New York, 1979.

Golgi-Stained Neuron and a Microelectrode.

Utilizing staining techniques, the architecture of nerve connections in a monkey brain is revealed. Microelectrodes are used here to measure electrical current signals flowing through nerves and to determine the localization of brain responses to visual stimulation. Lab of Dr. David Hubel and Dr. Torsten Wiesel, Harvard Medical School, Boston, Massachusetts, 1979.

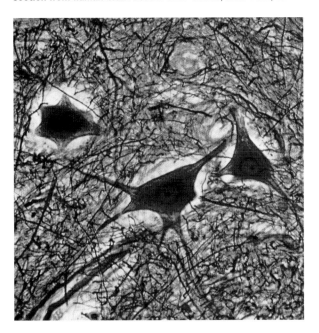

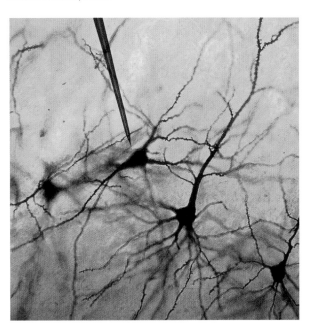

Neurons are very difficult to photograph because only a small part of them can be seen in focus. Tissue sections have to be very thick to show the whole neuron and to see them and the electrode at the same time, without background material obscuring them. This photograph took Fritz over a week to accomplish.

David Hubel
Department of Neurobiology
Harvard Medical School

This photograph shows a polymer pellet implanted in a rabbit cornea. The pellet is slowly releasing angiogenic activity from a partially purified extract of tumor cells. In 1976, angiogenic factors had not yet been purified. In fact, the first angiogenic factor was purified in our laboratory at The Children's Hospital by Michael Klagsbrun and Yen Shing in 1983. It turned out to be basic fibroblast growth factor (BFGF). Its complete amino acid sequence is known and its gene has been isolated. There are now at least eight angiogenic proteins that have been completely sequenced and their genes cloned.

The blood vessels in the photograph are most likely being stimulated. BFGF, the angiogenic factor most commonly used by a wide variety of cancers to stimulate their blood vessels, has been found to be abnormally elevated in patients with a wide variety of cancers, including breast cancer, brain tumors, bladder cancer, prostate cancer, colon cancer, and lymphoma.

Since this picture was taken, the field of angiogenesis research has expanded rapidly. Angiogenesis inhibitors have been discovered, and three of these are now in clinical trials in patients with cancer or with eye neovascularization. This photograph and article had an enormous impact. I have always thought the photograph itself compelled people to read the article.

Judah Folkman
Department of Surgery
Harvard Medical School
The Children's Hospital of Boston

MARINE LIFE

Water is the amnion of life, providing dissolved molecules for nurture and also serving for waste disposal. Life began in the sea as simple rounded cells like many bacteria, these evolved into myriad forms due to the rigors of the environment and biological competition. Microscopic single-cell organisms proliferate in all parts of the ocean, many millions being present in every cubic centimeter of water. Some make intricate latticework skeletons full of rococo ornamentation, mostly of glassy silica or crystalline limestone, each so distinct that scientists can accurately date old sediments from single-cell microfossils.

Multicellular life began as chains and sheets of single cells on the surface of shallow marine sediments. Cells that had acquired the genetic code to make the chlorophyll molecule could grow rapidly using sunlight, water, and carbon dioxide. Characteristic structures they built, called stromatolites, are found in the oldest sediments. By two billion years ago they had released so much waste oxygen to the environment that some cells evolved using oxygen for respiration. This allowed development of much more active organisms, the ancestors of protozoans, fungi, plants, and animals.

Multicellular organisms with distinct tissues and organs began with animals like corals and jellyfish. A baglike stomach is surrounded by a ring of tentacles with stinging cells for capturing smaller swimming animals. Improvements in digestion, armor, and mobility led to the explosive evolution of virtually all major marine groups, such as worms, snails, and clams around six hundred million years ago. These were soon followed by the fishes, the descendants of a segmented worm that developed an internal backbone allowing great strength and speed. From fishes came land vertebrates: the amphibians, reptiles, birds, and mammals.

Healthy marine ecosystems are animal dominated because most of the plants are small and are quickly consumed; so except for the tiniest grazers, animals generally eat each other. In contrast, land ecosystems are dominated by long-lived plants, and animals are relatively few, short-lived, and largely herbivorous. Under conditions of excessive nutrients, algae proliferate in shallow waters, overgrowing the bottom-dwelling animals. Coral reefs, the most biologically diverse marine ecosystems and the most sensitive to excess nutrients, are being smothered by algae wherever development causes sewage to be released to the sea. The extreme sensitivity of corals to high temperatures also places them at risk from global warming.

Fish-Egg Eyes.
Fish eyes develop very early in the eggs of this coral-reef fish, collected by Dr. Thomas F. Goreau. Discovery Bay Marine Laboratory, Jamaica, 1968.

Stromatolites.

Structures formed by billion-year-old fossil algae
are the earliest evidence of life on earth. The
chains of tiny cells grow upward to the light
during the day, but horizontally at night, trapping
minute layers of sediment. 1971.

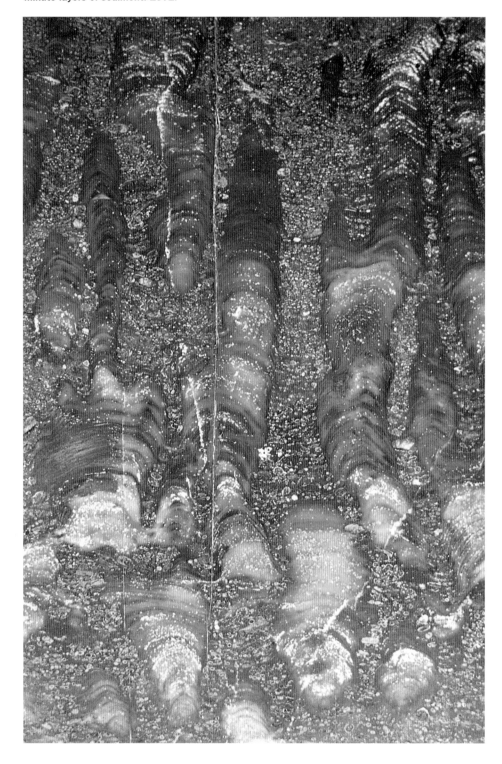

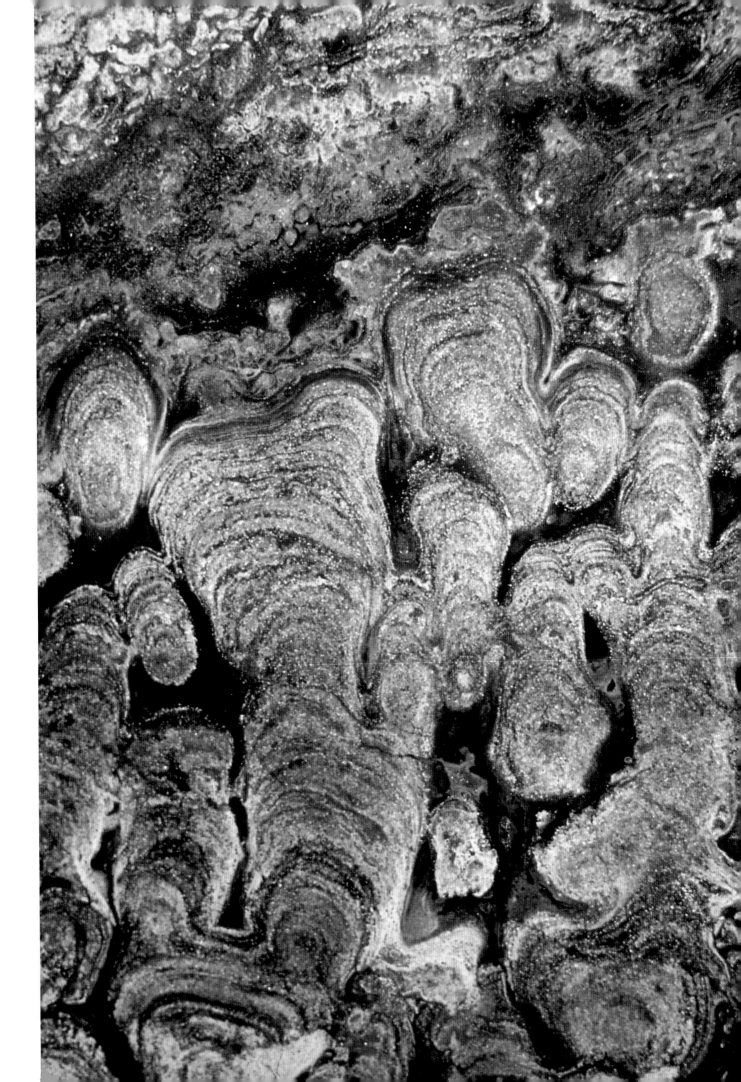

Marine Microfossils.

The minute glassy opal skeletons of unicellular marine animals fall
to the ocean floor after death. These samples were prepared by
Dr. William Riedel of the Scripps Institution of Oceanography and
Dr. James Hays of the Lamont Doherty Geological Observatory. Goro
photographed the samples using Nomarski contrast interference optics.
Goro Studio, 1976.

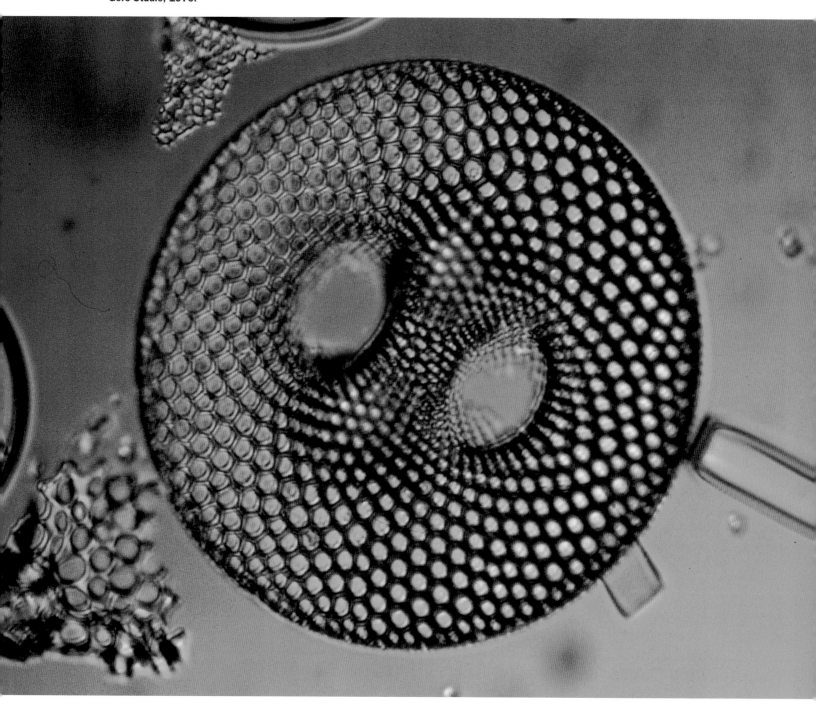

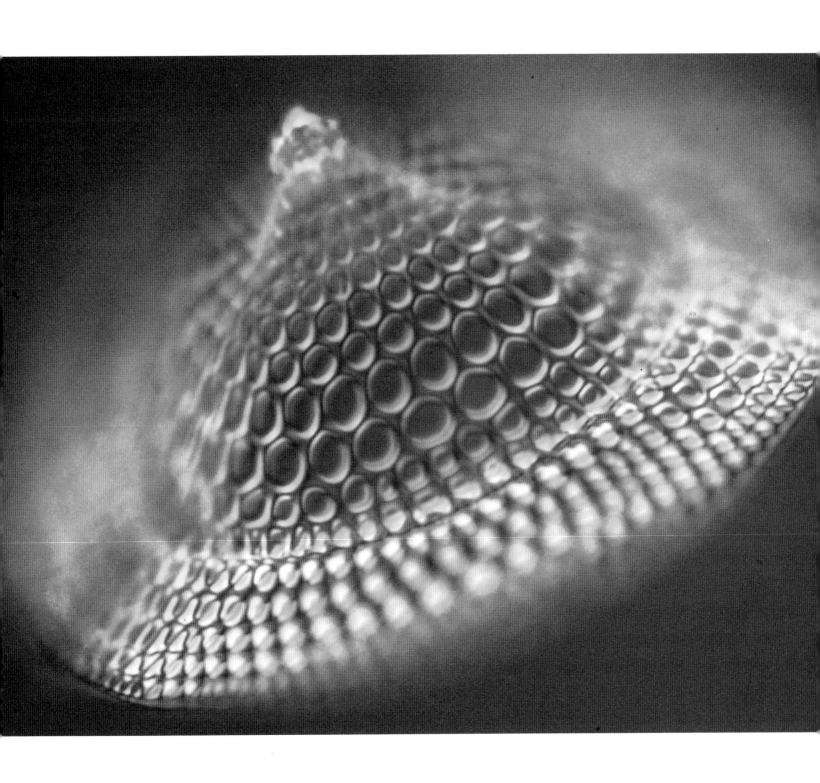

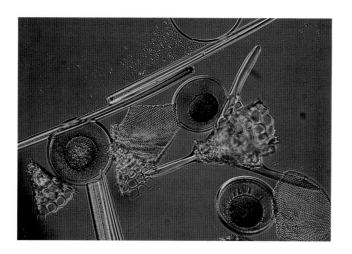

Radiolaria.

The organisms that make these skeletons are called Radiolaria, minute single-celled floating animals that often live from food made by the photosynthesis of smaller symbiotic algae that live inside them. Each species has its own distinctive architecture. Changes in the shape of Radiolaria species as they evolve through time allow scientists to date accurately the deep-sea sediments in which their skeletons are found. Goro Studio, 1976.

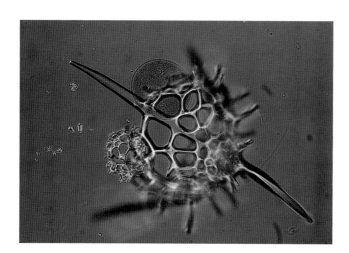

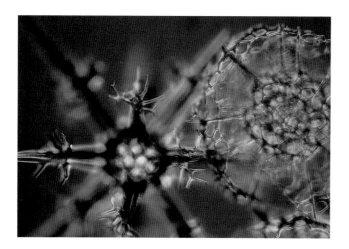

The Radiolaria have beautifully symmetrical, glassy skeletons of silica. Though the skeleton is colorless, Fritz was able to bring out significant structural features to striking effect by introducing colors into their illumination. In the course of our collaborating on this project, he inspired us, as paleontologists, to explore ways of increasing the impact and information content of our usually prosaic, gray-scale illustrations.

William R. Riedel
Scripps Institution of Oceanography
University of California, San Diego

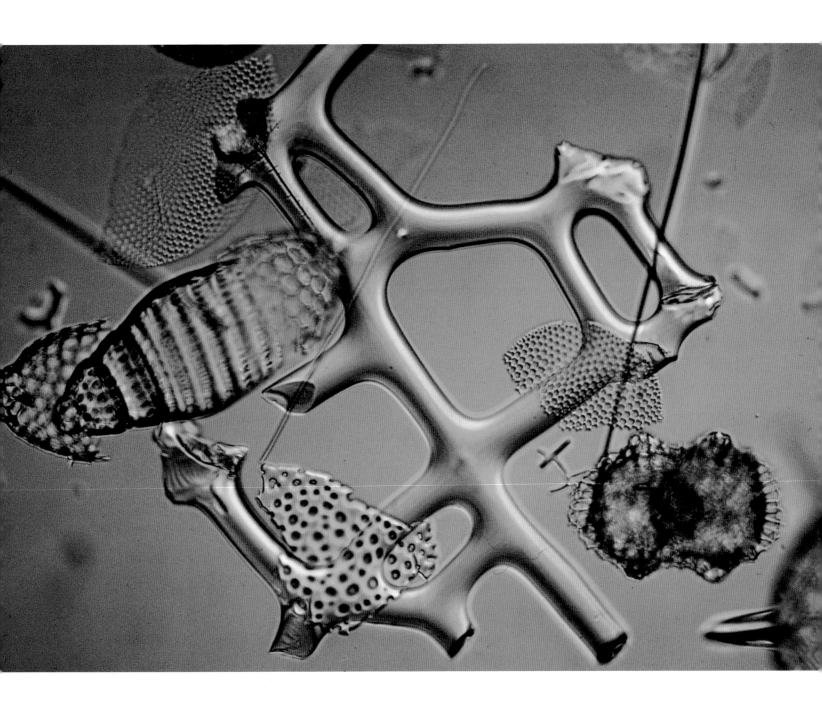

Deep Sea Drilling Ship.

The specially made deep ocean drilling ship *CUSS 1*, operating at night. Pacific Ocean, Mexico, 1961.

Opposite: Professor Walter Munk (left) and Dr. William Riedel look at the first core samples of deep ocean sediments brought up by the drill. Pacific Ocean, Mexico, 1961.

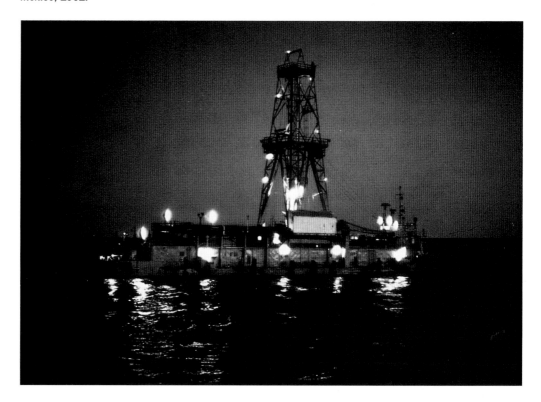

The overall objective of the Mohole Project in 1961 was to obtain a sample of the rock of which the earth's mantle is composed. We intended to demonstrate that it was possible to drill in water as deep as 12,000 feet; at the time the world record was 360 feet. There were a number of engineering questions about how to retrieve cores of bottom material and how to measure the nature of the hole walls without removing the pipe from the hole. When we tested our solutions to those problems, the result provided several valuable scientific findings. It was this part of the work that Fritz Goro photographed so successfully. We also had several breakthroughs. I contributed the concept of dynamic positioning, which made it possible to hold a ship in position above a drill hole in water too deep to anchor. Other members of our team invented the "guide-shoe" to reduce pipe bending when the ship rolled, and equations for calculating pipe stresses. The project was a success; we had proven that it was possible to do just about anything in deep water that could be done on land. On the evening of April Fool's Day, 1961, we reached our greatest penetration (600 feet below sea bottom). At that depth we first sampled the previously unknown "second layer" of the ocean's crust, which turned out to be basalt.

Willard N. Bascom
Former Research Associate
Scripps Institution of Oceanography
University of California, San Diego

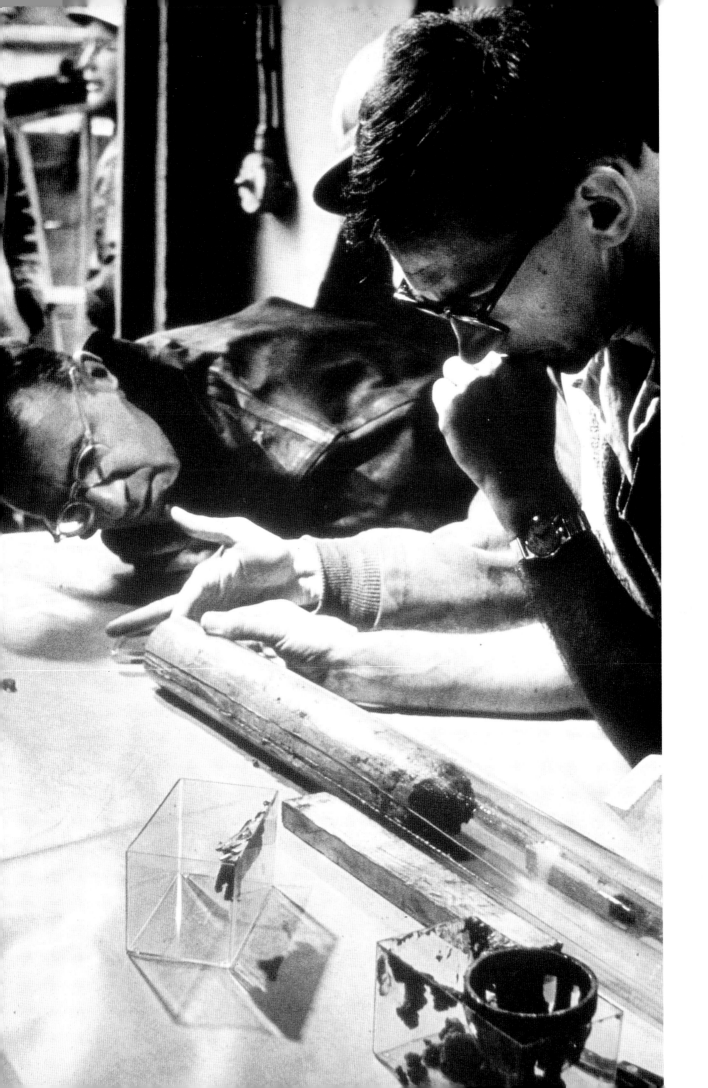

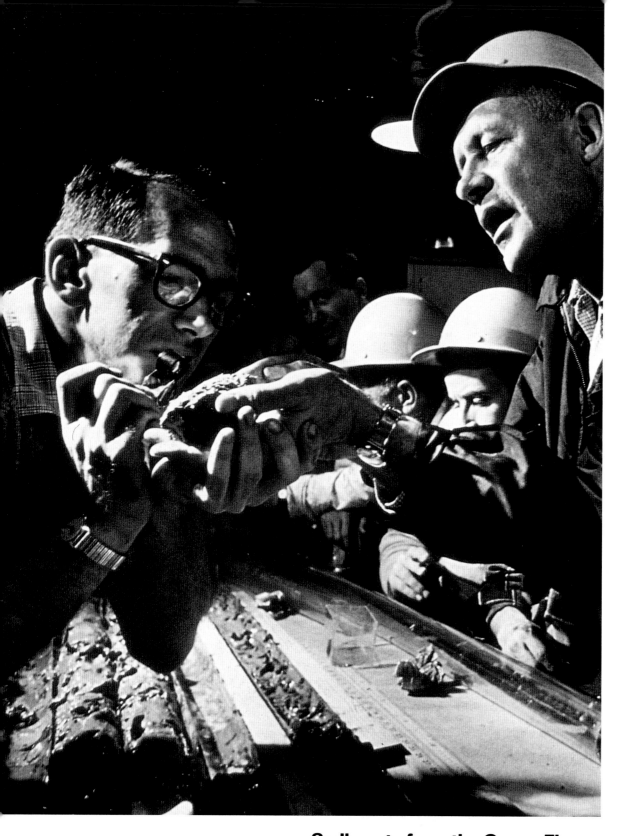

Sediments from the Ocean Floor.
Dr. William Riedel (left) looks through a magnifying glass at the first microfossils taken from sediments in the core while Professor Roger Revelle (right) watches. This material allowed determinations to be made of the age and environmental conditions at time of deposition and provided dramatic proof of sea-floor spreading. Pacific Ocean, Mexico, 1961.

Microfossils on a Glass Slide.

Radiolaria, the size of a grain of sand, ready for viewing by microscope aboard the *CUSS 1*. Pacific Ocean, Mexico, 1961.

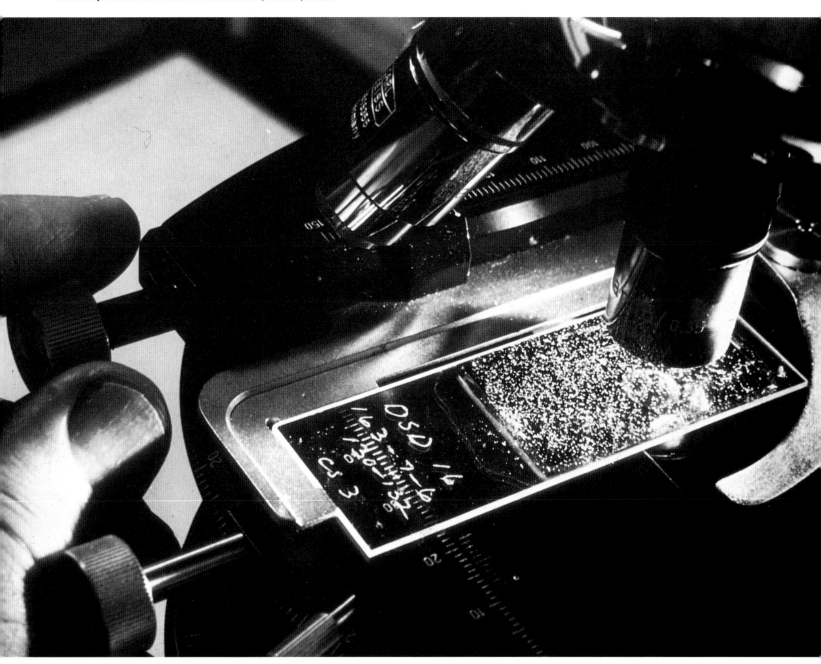

I remember our exciting week aboard the CUSS 1, *off Guadalupe Island. We drilled a hole in 12,000 feet of water; the drill penetrated 600 feet of sediment and a few feet of basalt. This was the first ever that anyone had drilled in the deep sea. Fritz Goro and John Steinbeck were along to record the event for* Life *magazine. The drilling vessel,* CUSS 1 *of Global Marine, had performed admirably; the vessel was constantly underway, driven by four large outboard propellers to maintain a fixed position relative to three sonic bottom transponders, the first example of "dynamic positioning." Waves were high, as a result of my poor choice of a site, which I had imagined would be in the lee of the island. Instead, the island had a funneling effect and the drilling spot was in the roughest area. It was terribly noisy, and we all lost our voices after the first two days, but in the end, things worked out.*

Walter H. Munk
Scripps Institution of Oceanography
University of California, San Diego

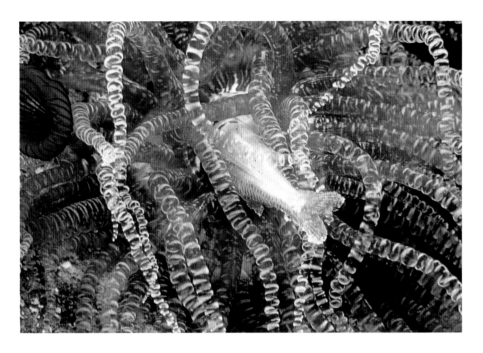

Sea Anemone Swallowing Fish.

The stinging cells of this attached anemone have paralyzed a fish and the tentacles are pushing it into its stomach. Great Barrier Reef, Australia, 1950.

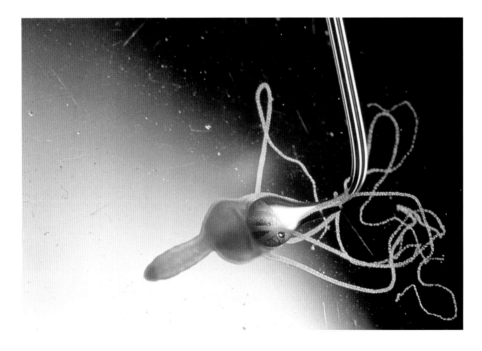

Hydra Swallowing Glass Bead.

The feeding response of the hydra has been elicited by coating a glass bead with the chemical glutathione, 1965.

Digestive Filament from a Jellyfish Stomach.

These filaments from a Portuguese man-of-war contain stinging cells and release enzymes used to break down and absorb the food they catch. Lab of Dr. Howard Lenhoff, Miami, 1968.

File Shell.

The long arms and bright red body of a
jumping scallop photographed at the Lerner
Marine Laboratory. Bimini, Bahamas, 1952.

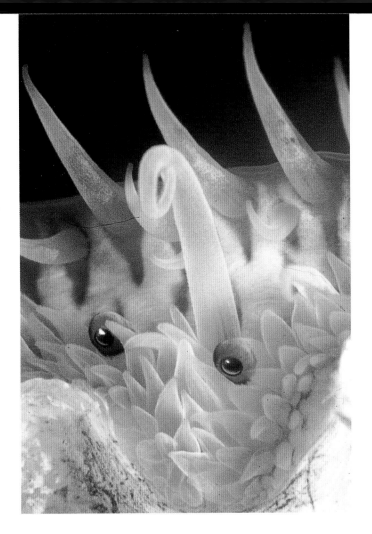

Scallop Eyes.
The eyes of the bay scallop are a startling deep blue. Specimen provided by the New York Aquarium. Goro Studio, New York, 1976.

Pacific salmon die a few days after their life's work is finished. Their rapid demise provides biologists with a provocative model for the degenerative processes occurring in human aging. Such study, envisaged by Pete Scholander, engendered a research expedition of the biological research vessel Alpha-Helix, of which I was principal investigator. Fritz was a member of this scientific group. His energy and enthusiasm amazed everyone. He followed the life of the salmon from their birth in the shallows of the mountain riverbed, to their life in the ocean, to their demise after spawning at the place of birth. He had photographed the sea algae whose yellow pigments were converted to the red color of the copepods, tiny crustaceans (with red temporarily disguised as blue in their eggs), and the final storage of the red pigment in the muscle of the salmon. As the energy of the salmon is depleted in their effort to return to their birthplace, the red astaxanthin pigment is preserved in the eggs, but gone from the muscle. The flesh of the dying salmon was a deathly gray-white. Fritz photographed countless pairs of salmon, which, remarkably, appeared to have remained mates in death as they had been in the flowing water of the spawning beds of coarse gravel.

Andrew A. Benson
Scripps Institution of Oceanography
University of California, San Diego

Copepod.
Microscopic shrimplike animals, which eat tiny single-celled algae, are the basis of many marine food chains. Taken aboard the research vessel *Alpha-Helix*, British Columbia, 1975.

Microscopic Life.
Minute organisms in a drop of water from a New Hampshire estuary, including algae and the small animals that eat them. Jackson Laboratory, University of New Hampshire, Durham, 1975.

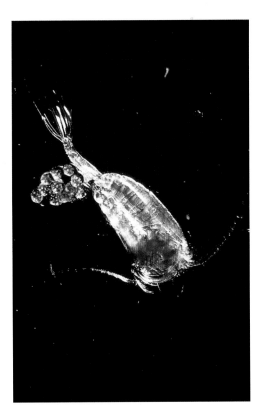

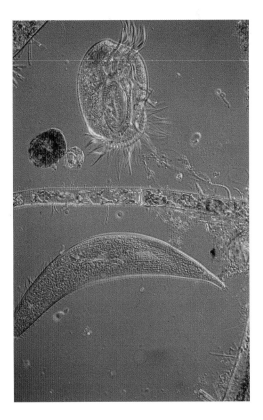

Salmon Eggs.

The eggs of the salmon have the deep, rich orange color of the flesh of the adult fish. British Columbia, Canada, 1975.

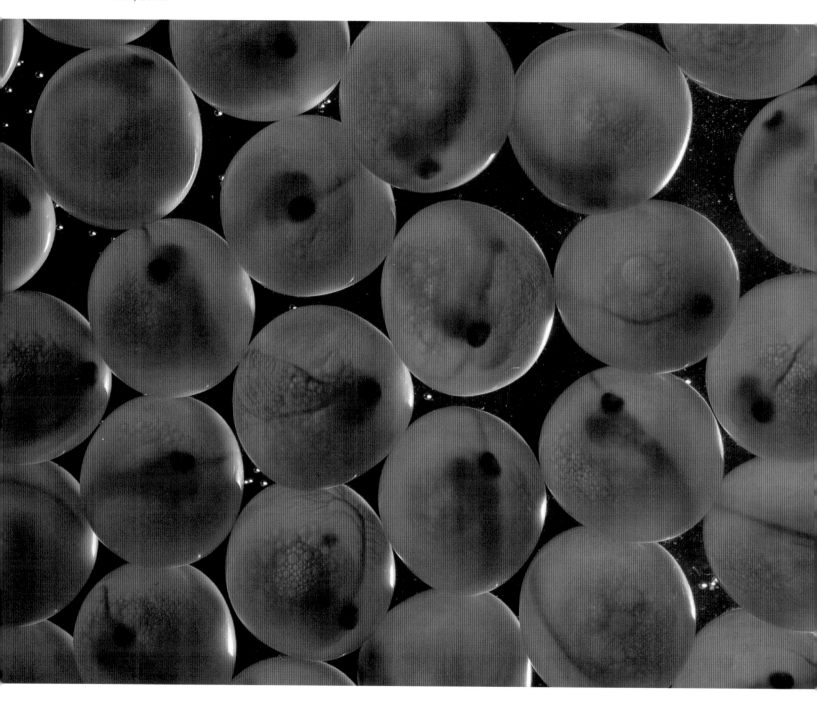

Sea Urchin Teeth.

The five teeth of the common Caribbean sea urchin *Diadema antillarum.* This structure, called the "Aristotle's lantern," is used to scrape algae down to bare rock. Bimini, Bahamas, 1952.

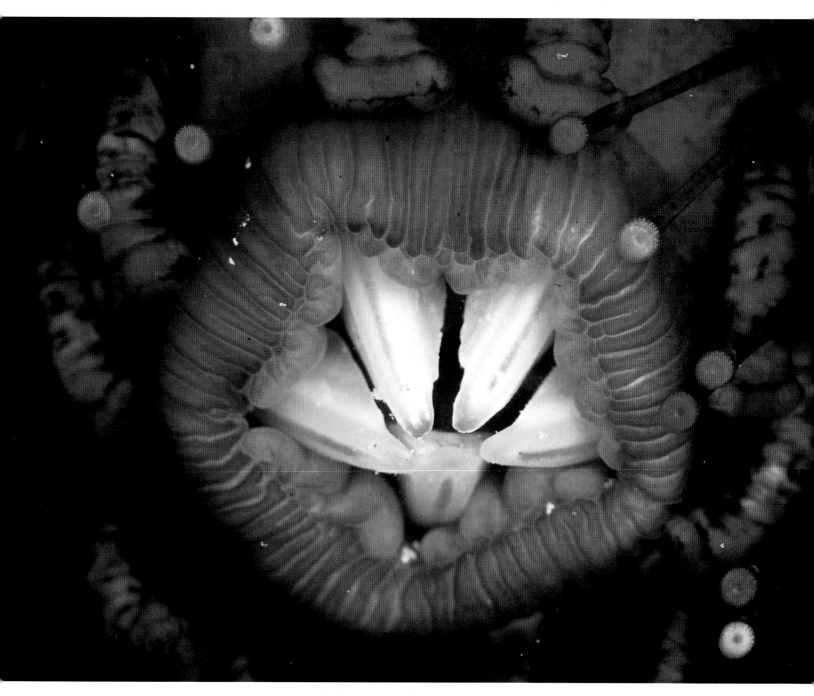

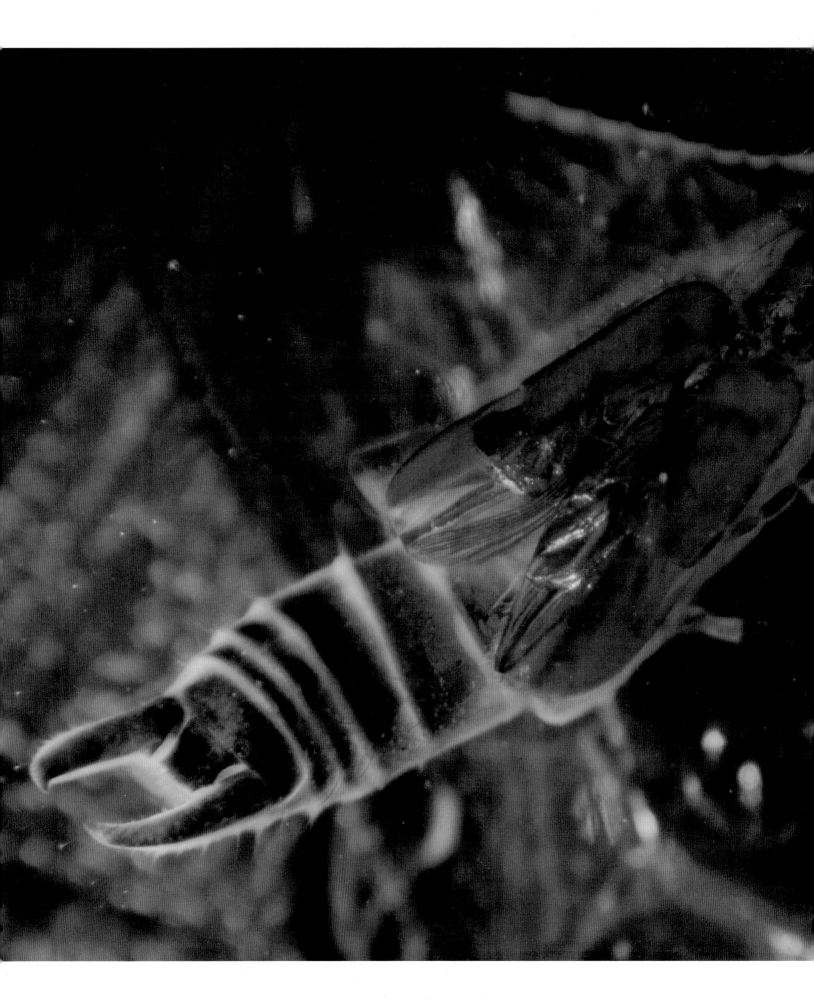

TERRESTRIAL LIFE

Terrestrial life began when algae adapted to air exposure and evolved into land plants, followed immediately by the appearance of insects and earthworms. Presumably the subaerial globe had long been colonized by wind-dispersed bacterial spores, and was covered in a thin coat of biological slime, promoting rock weathering and development of soils in which new plants found niche and nourishment. Insects, evolving from marine animals with external skeletons like those of shrimps and crabs, established early dominance among animals, a position they enjoy today despite extremely sophisticated vertebrate insectivores.

It is natural for us to regard our own group as most important, but the majority of all known species of life on earth are either insects or flowering plants. The proliferation of these two groups is due to their coevolution, insects relying on plants for food and shelter, and plants relying on insects to disperse their pollen and seeds. The most extraordinary preservation occurs when insects are trapped in the resinous sap of certain species of trees turned to amber in sediments. These iridescent nuggets perfectly preserve intricate ecological information, even DNA.

The biosphere has been greatly changed by humankind. We have altered or eliminated habitats and lost species, while increasingly disrupting ecological links on which surviving species rely. At the same time, we have triggered rapid evolution of species that depend on human density, such as parasitic diseases like malaria and AIDS, or weed plants and insect pests that proliferate wherever humans have disrupted the environment. Modern molecular biology can allow the cloning of cells whose DNA instructions have been precisely altered to enhance or suppress certain sequences of information.

We are now in an evolutionary competition with the inadvertent results of our own actions. Our future is intimately tied to the natural biospheric processes, which regulate our climate, water, and air quality. Their protection requires more than just saving isolated species in reservations; it requires preserving the entire structure of symbiotic and coevolutionary interactions that link them and that maintain their global bio-geo-chemical health.

Fossil Earwig.
Close-up of a fossil earwig in amber,
from the collection at the Museum of
Comparative Zoology, Harvard University.
Goro Studio, New York, 1982.

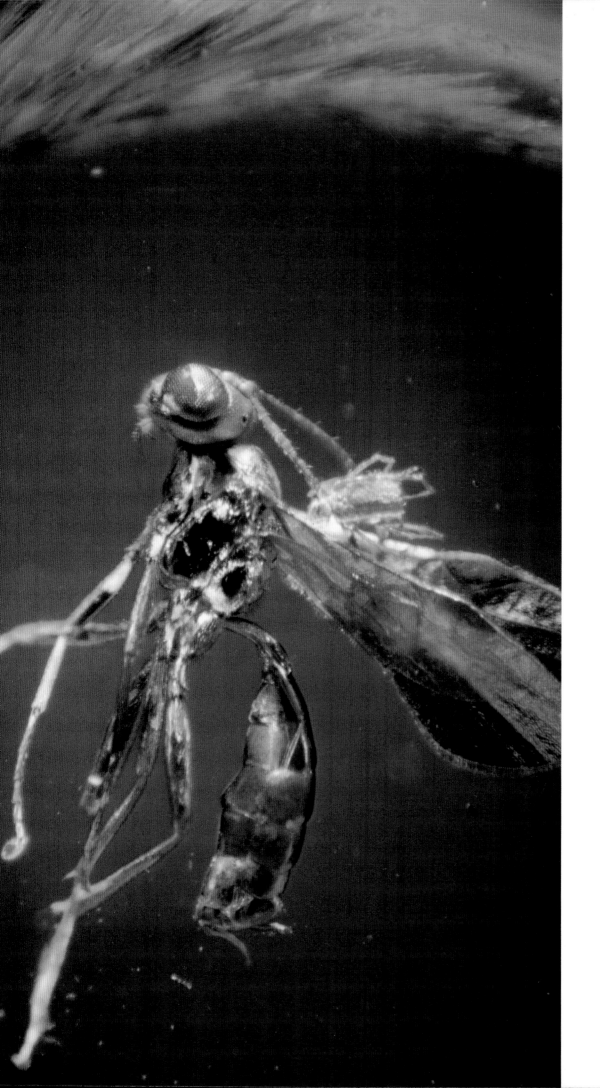

Fossil Wasp.
A thirty-eight-million-year-old wasp,
perfectly preserved in amber from the
Baltic, in the collection at the
Museum of Comparative
Zoology, Harvard University.
Goro Studio, New York, 1982.

Fossil Fly.
A fly, preserved in amber after it
was trapped in a drop of resinous
sap, from the collection at the
Museum of Comparative Zoology,
Harvard University. Goro Studio,
New York, 1982.

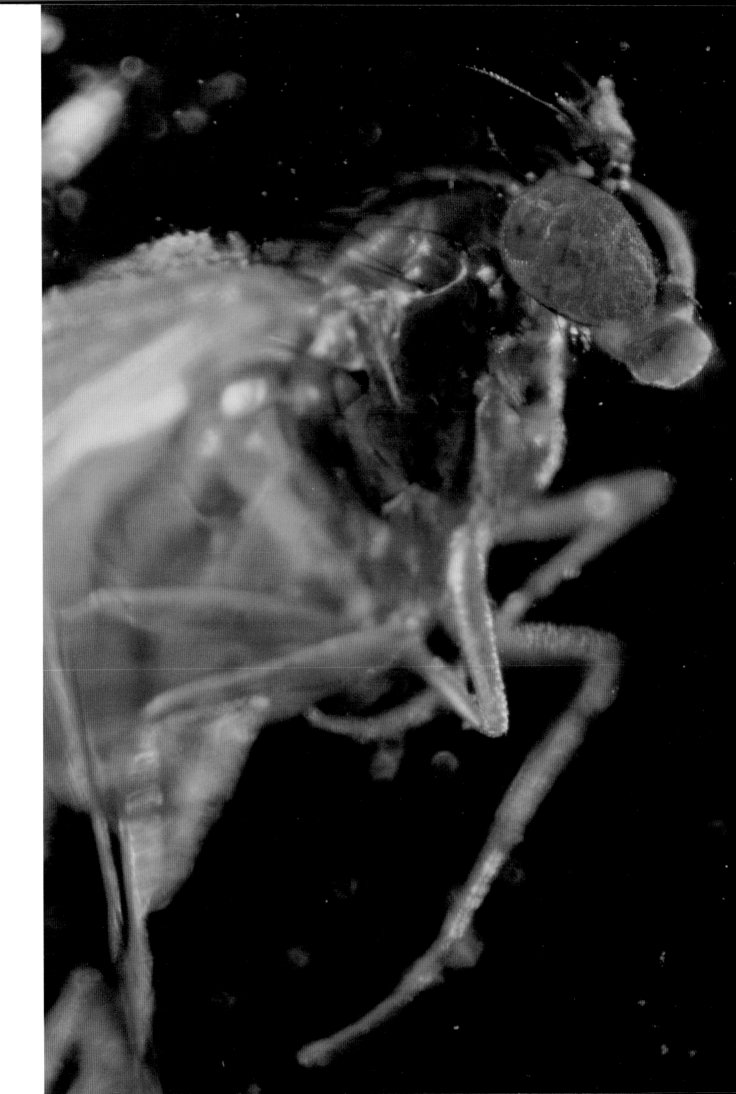

**Scales on
Butterfly Wings.**
Microscopic scales on a butterfly wing.
Goro Studio, New York, 1981.

South American Railroad Worms.

Held in a glass dish by Dr. Newton Harvey at the Marine Biological
Laboratory. Commonly called railroad worms, they are actually
the larvae of a beetle. Woods Hole, Massachusetts, 1945.

Two-Color Luminescence
of Railroad Worms.

In the dark, the railroad worm shows its unique
characteristic, the only organism that gives off
luminescence in two colors. These pictures,
showing crawling and curled-up larvae, are
self-portraits made by exposing the film to the
direct light of the worm on top of it.
Woods Hole, Massachusetts, 1945.

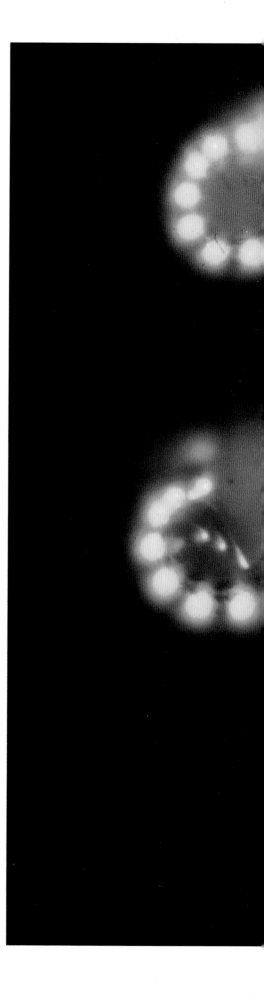

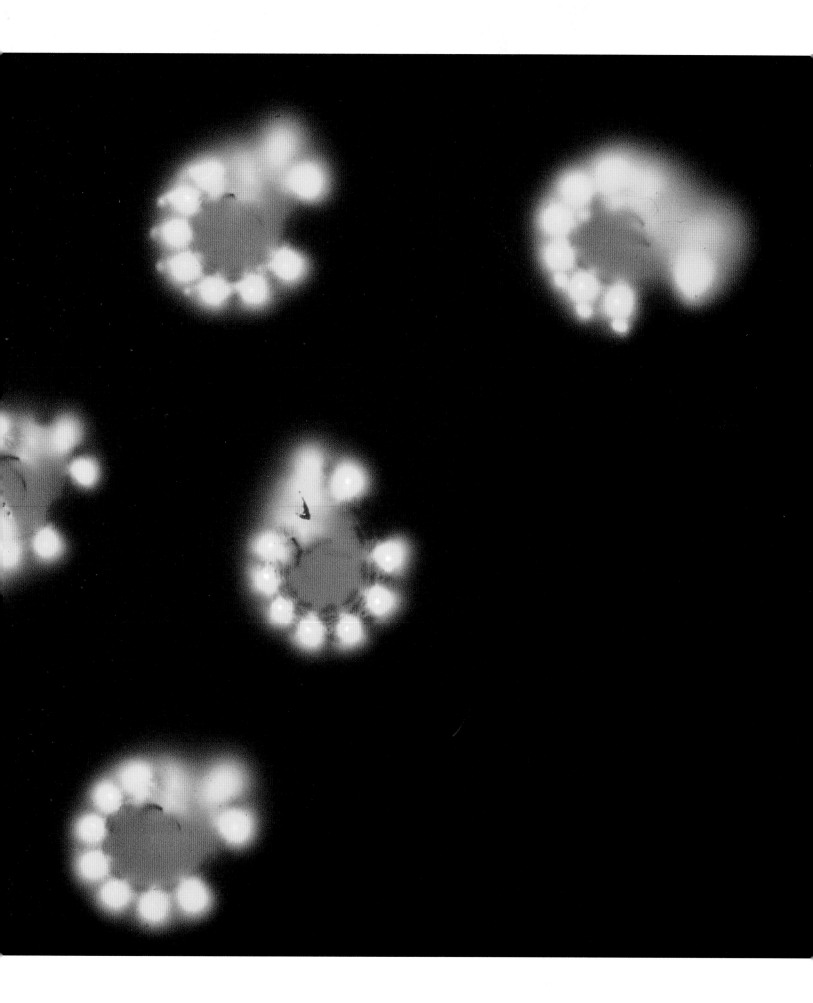

Fly Eye.
Reflection of light from rows of eyes
creates a shimmering illusionary
pattern. Goro Studio, New York, 1982.

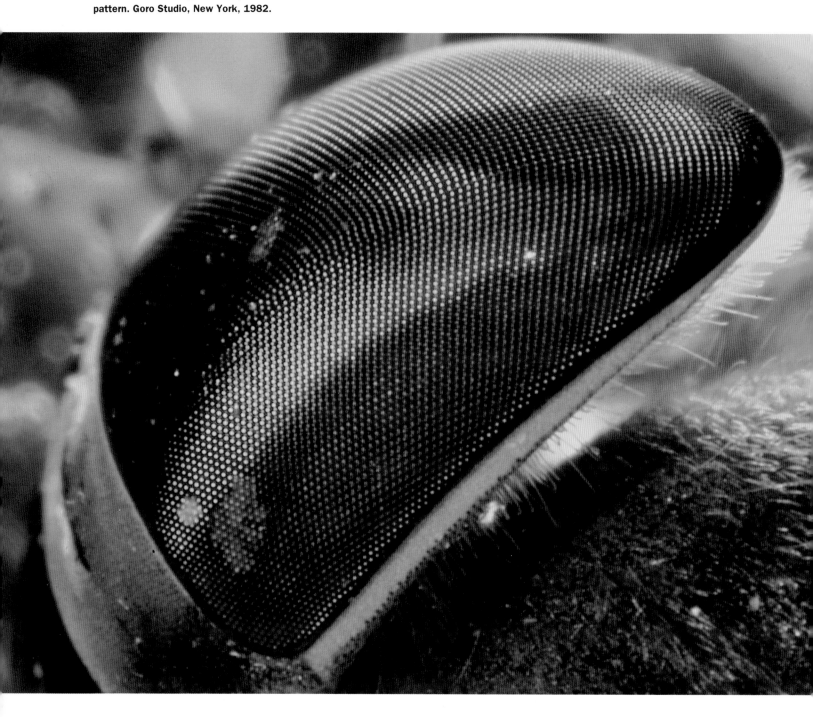

Fly Eye.
Close-up of hexagonal packing of the compound
eyes of a fly makes a regular spherical pattern.
Goro Studio, New York, 1982.

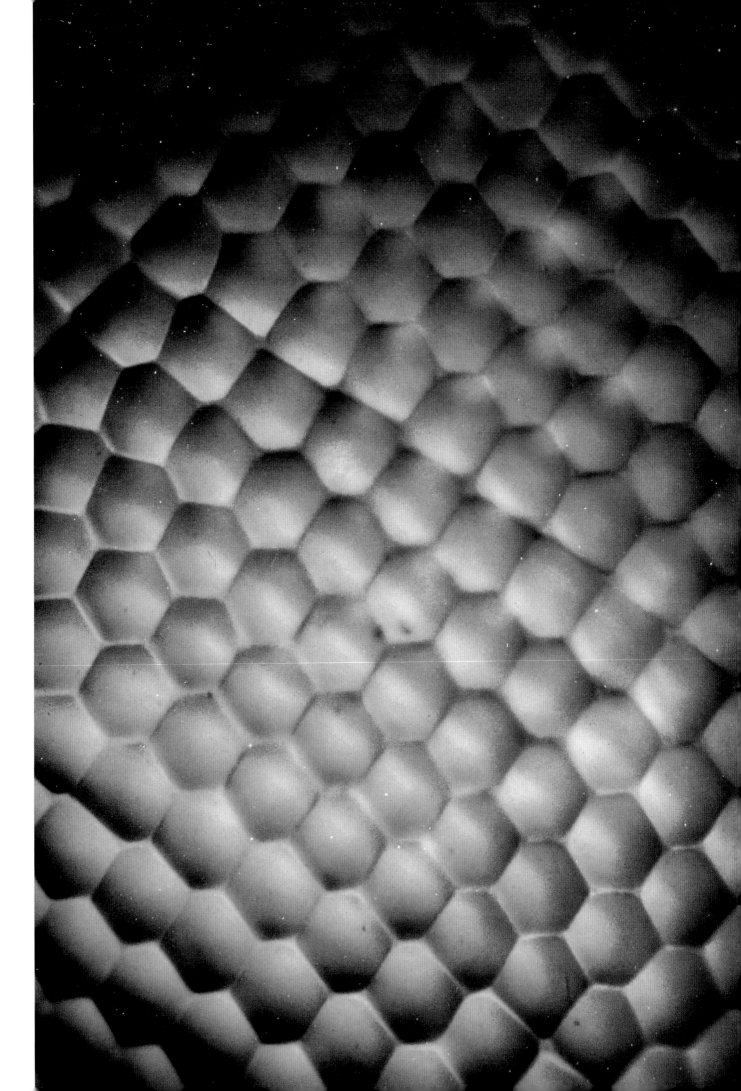

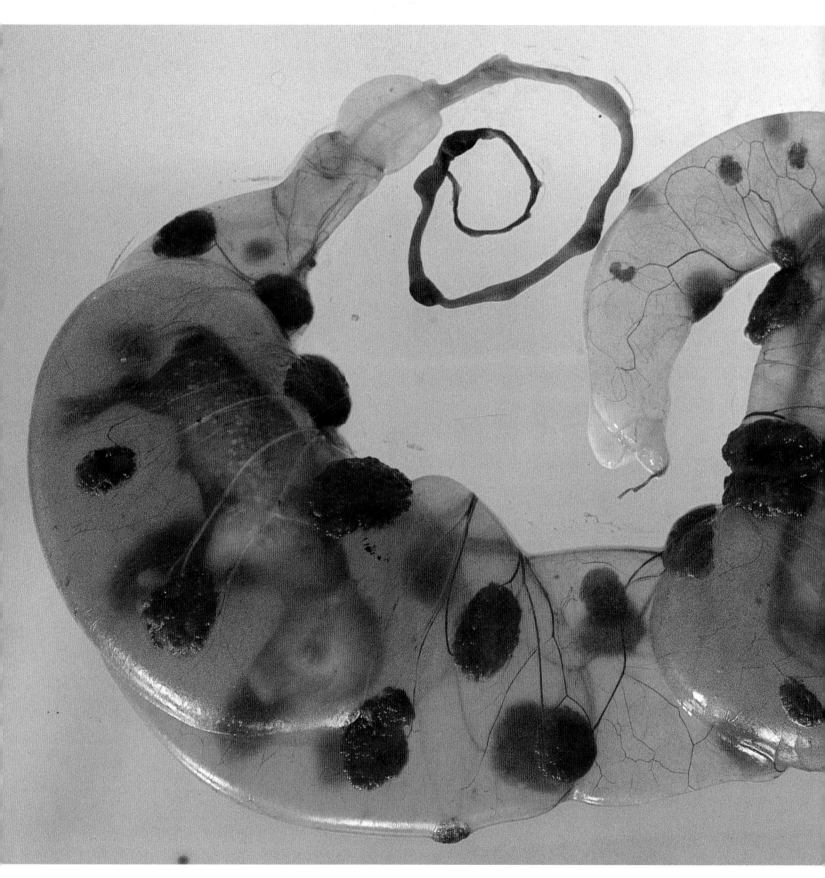

Fertility Drug Effects.
The placenta of a cow treated with fertility drugs by Dr. Victor Hafez
produces multiple births. Pullman, Washington, 1965.

Aphid Wired to a Microelectrode.
Connected by a wire to a microelectrode that monitors its activity, an aphid crawls across a leaf in an agronomy laboratory at Cornell University. Ithaca, New York, 1965.

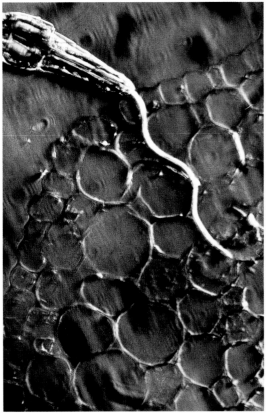

Aphid Sucking Plant.
Photomicrograph showing the stylet of the aphid's mouth piercing a single plant cell and sucking out its contents. Ithaca, New York, 1965.

First Prenatal Surgery.

The first prenatal surgery performed on an unborn baby rhesus monkey. The baby was then returned to the mother's womb to continue gestation to normal birth. Nearly thirty years later, this technique is now being used to save human children who would have died in the womb. Oregon Primate Research Center, Beaverton, Oregon. 1965.

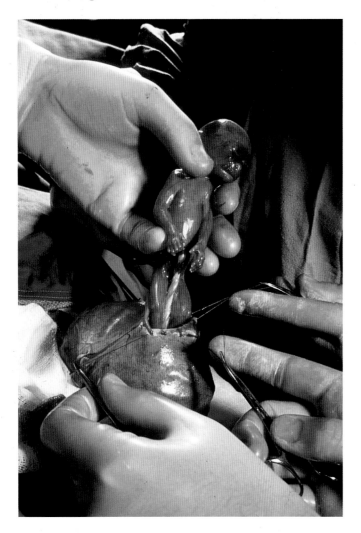

Fetus in Tank.

A miscarried fetus is kept alive in a glass and steel artificial womb at Stanford University. This picture was the inspiration for a famous scene in the movie *2001: A Space Odyssey*. Dr. Robert Goodlin, whose research at Stanford University is shown, found a hostile response from antiabortion groups after the picture was published in *Life* magazine. He said, "I was trying to save the lives of babies, but I was luridly depicted as a mad scientist who delighted in torturing fetuses. I didn't know how to fight it. Merely explaining rationally what I was trying to do didn't work at all, and I was finally forced to abandon the project." Palo Alto, California, 1965.

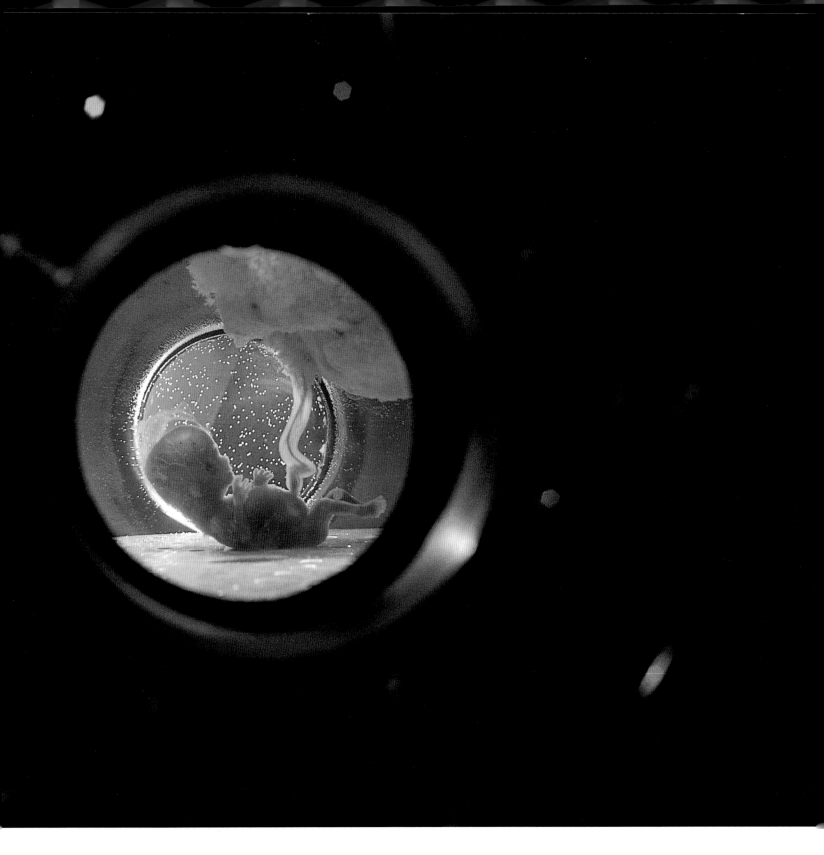

Fritz Goro was the person who, first in the world, documented the most important discoveries in medicine, physics, chemistry, and, not least, rocks from the moon for the rest of us. Thanks to his singular photographic techniques, and together with the most prominent scientists, he visualized processes and properties in cancer, the DNA molecule, holography, lasers, and the most powerful of modern technologies—nuclear science—in remarkable photographs that were taken from as early as the mid-1930s until 1986. These images were sensational then as now. No one has done them better!

Lennart Nilsson
Karolinska Institute
Stockholm, Sweden

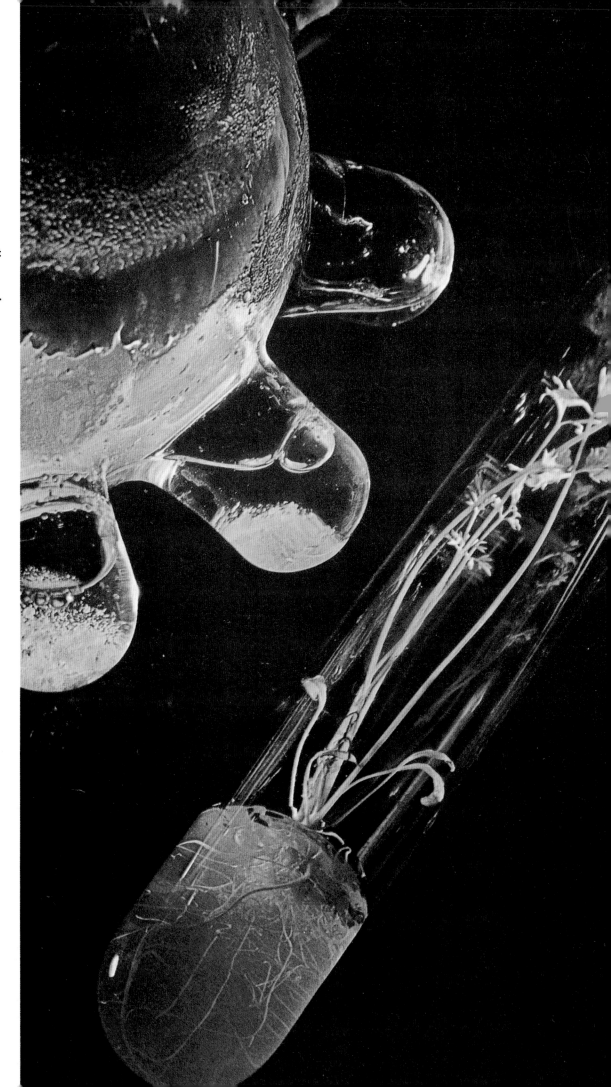

Carrot Plant Cloned from a Single Cell.

The first development of plant tissue culture techniques permitting the cloning of a whole plant from a single cell. Ithaca, New York, 1965.

Extraction of Carrot Cells for Cloning.

Small fragments of carrot are extracted for use in cloning. Laboratory of Professor Francis Steward, Cornell University, Ithaca, New York, 1965.

Bean Plant.

Studies of photosynthesis in the laboratory. Ithaca, New York, 1965.

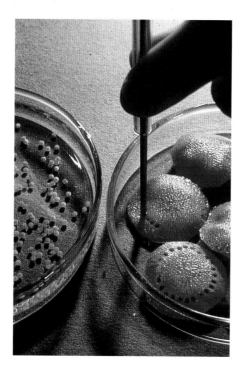

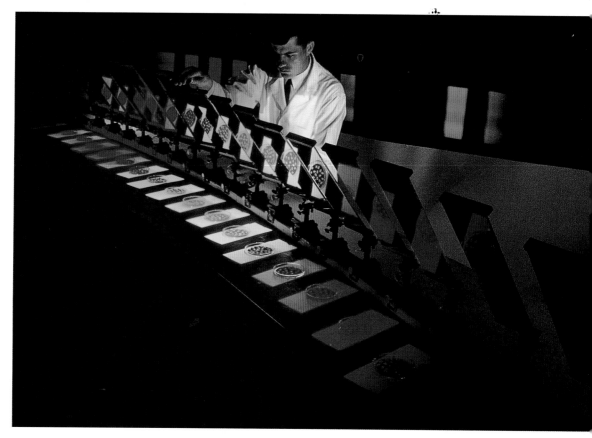

Spectral Response of Corn Germination.

Germinating corn seedlings are illuminated by different wavelengths of light from a giant spectrograph in experiments at the Argonne National Laboratory. Chicago, Illinois, 1965.

CONTRIBUTING SCIENTISTS

1. **FREDERICK J. ALMGREN, JR.,** is a professor of Mathematics at Princeton University, specializing in geometric measure theory and the calculus of variations. He received his Ph.D. in Mathematics from Brown University, after which he joined the faculty of Princeton. His research has focused on the geometry of minimal surfaces, including modeling soap films and soap-bubble clusters. He has also studied geometric evolution processes, such as those modeling the growth of snowflakes. Almgren is a member of the Geometry Group of the National Science and Technology Research Center for Computation and Visualization of Geometric Structures, in Minneapolis. He was elected a Fellow of the American Association for the Advancement of Science in 1982, and he is the editor of several mathematics journals. Almgren has authored a book, *Plateau's Problem*, a number of research and exposition articles, and a computer-generated mathematics video. He has lectured throughout the United States and Eastern and Western Europe.

2. **WILLARD N. BASCOM** has been working since 1987 as an underwater archaeologist on projects in Turkey, Russia, and Greece. He received his education from Springfield College in Massachusetts and the Colorado School of Mines. After working as a mine supervisor, Bascom served as a field research engineer for the Mechanical Engineering Department at the University of California, Berkeley. He went on to the Scripps Institution of Oceanography, University of California at San Diego. From 1959 to 1962 he was the director of the Mohole Project. Among Bascom's honors was the naming of the U.S. Maritime Administration's research vessel, the *Willard Bascom*. He has been a consultant for the Environmental Protection Agency, a member of the Atomic Energy Commission, the Naval Research Advisory Committee, and the U.S. Army Corps of Engineers' Coastal Engineering Research Board.

3. **ANDREW A. BENSON** is a current member of the Advisory Council of the Cousteau Society, and the Advisory Board of the Marine Biotechnology Institute Company, Ltd., in Tokyo. He received his Ph.D. in Chemistry from the California Institute of Technology. Among his many research and teaching positions, Benson has taught at Berkeley, Penn State, and UCLA. From 1944 to 1946 he was a Research Associate for the Civilian Public Service at Stanford, where he worked on antimalarial drug synthesis research with Professor F. W. Bergstrom. From 1962 to 1989 Benson was a professor of Biology at the Scripps Institution of Oceanography. From 1978 to 1986 he was on the Advisory Panel to NASA for Space Biology. In 1962 he won the Ernest Orlando Lawrence Memorial Award from the Atomic Energy Commission for development of radiotracer methods in biology. Benson used the first available quantity of radioactive carbon to study the path of carbon in photosynthesis. Among Benson's discoveries were the identification of the first product of photosynthesis, the recognization of wax as the major marine nutritional energy source, and the utilization of spawning salmon as a model for the study of degenerative processes of aging in humans.

4. **MOSES JUDAH FOLKMAN** is professor of Pediatric Surgery, Anatomy, and Cellular Biology at Harvard Medical School, and Senior Associate in Surgery and director of the Surgical Research Laboratory at the Children's Hospital Medical Center in Boston. He received his M.D. from Harvard Medical School. As a student at Harvard, he worked in Dr. Robert Gross's laboratory, where he developed the first atrioventricular implantable pacemaker, for which he received the Boylston Medical Prize, the Soma Weiss Award, and the Borden Undergraduate Award in Medicine. At the National Naval Medical Center in Bethesda, Maryland, Folkman, with David Long, first reported the use of silicone rubber implantable polymers for the sustained release of drugs. This study led to the direct development of Norplant, the implantable contraceptive. His research on angiogenesis has opened up worldwide studies into treatments for cancer and other diseases. Folkman received a ten-year Merit Award from the National Cancer Institute in 1989, has been elected a Fellow of the American Association for the Advancement of Science, and is a member of the National Academy of Sciences.

5. **STEPHEN JAY GOULD** is a professor of Geology and Zoology at Harvard University, and the Curator of Invertebrate Paleontology at the Museum of Comparative Zoology. He received his Ph.D. from Columbia University and has taught at Harvard since 1967 as a professor of Geology, and since 1982 as a professor of Zoology. His books and magazine articles have made him one of the most widely read science authors of our time. Gould has received over thirty honorary degrees and numerous awards. Among his literary awards are the 1981 National Book Award in Science for *The Panda's Thumb*; the 1982 National Book Critics Circle Award in general nonfiction for *The Mismeasure of Man*; and the 1983 Outstanding Book Award from the American Educational Research Association for *The Mismeasure of Man*. In 1991 Gould was a nominee and finalist for the Pulitzer prize in nonfiction for *Wonderful Life*. Gould has served on the editorial boards of *Systematic Zoology*, *Paleobiology*, and *American Naturalist*. He currently is on the board of editors of *Science* magazine.

6. **DAVID HUNTER HUBEL** is a John Franklin Enders University Professor in the Department of Neurobiology at Harvard University Medical School, and a Senior Fellow in the Harvard Society of Fellows. He received his M.D. from McGill University Medical School. He has been a professor of Neurophysiology and Neuropharmacology at Harvard since 1959. His research in neurology has won him a number of awards from medical societies, and in 1981 he received the Nobel prize in medicine. Hubel is the author of nearly one hundred medical publications, and he lectures worldwide. He served as assistant resident in Neurology at Johns Hopkins Hospital and was subsequently a Research Fellow at Johns Hopkins University.

7. **EMMETT N. LEITH** is a professor of Electrical Engineering and Computer Science at the University of Michigan, where he has taught since 1965. He received degrees in Physics and a Ph.D. in Electrical Engineering from Wayne State University. He was Assistant Head of the Radar and Optics Laboratory at Willow Run Laboratories from 1964 to 1970. Leith has been a consultant to IBM and Chicago Nuclear, and is a member of the Optical Society of America and the Institute of Electrical and Electronics Engineers. His specialty is holography, and in 1976 he received the Inventor of the Year Award from the Association for the Advancement of Invention and Innovation. Leith traveled to Siberia for the National School of Holography, sponsored by the Soviet Academy of Science, and was the United States representative at the International Commission on Optics. He has authored over one hundred journal articles.

8. **JEROME Y. LETTVIN** is a professor of Neuroengineering in the Department of Biomedical Engineering at Rutgers University, a consultant in Neurophysiology at Boston City Hospital and Beth Israel Hospital, and a lecturer on Neurology at Harvard University Medical School. He received his M.D. from the University of Illinois. From 1966 to 1988 Lettvin was a professor of Communications, Physiology, and Bioengineering in the Departments of Biology, Electrical Engineering, and Computer Science at the Massachusetts Institute of Technology. He was the Senior Consulting Psychiatrist at the Boston Psychopathic Hospital, and Senior Psychiatrist at Manteno State Hospital, Illinois. He is a member of the American Physiological Society and the American Board of Psychiatry.

9. **WALTER H. MUNK** is a professor of Geophysics at the Scripps Institution of Oceanography. He received his Ph.D. from the University of California and since 1947 has been a professor of Geophysics and Planetary Physics at the university. He served as Chairman of the National Academy of Sciences' Geophysics Section from 1975 to 1978, and as chairman of the Ocean Studies Board from 1985 to 1988. He has had several Guggenheim Fellowships, a Fulbright Fellowship, and received the National Medal of Science in 1985. In 1986 Munk received an honorary doctorate from the University of Cambridge, England.

10. LENNART NILSSON is a photographer and Honorary Doctor of Medicine at the Karolinska Institute, Stockholm, Sweden. He has long been considered one of the world's leading medical and scientific photographers. Working with scientists and institutions worldwide, Nilsson has used photographic accessories and microscopes that are custom-made to record the world of the human body, and has pioneered the use of scanning electron microscopes for scientific illustration. His book *A Child is Born* has been translated into eighteen languages and has become a classic. His photographs have been published in *Life*, *Time*, *National Geographic*, and other leading magazines the world over. In 1983, his documentary film *The Miracle of Life* received an Emmy Award.

11. ILYA PRIGOGINE is the director of the International Institutes of Physics and Chemistry, director of the Ilya Prigogine Center for Studies in Statistical Mechanics, Thermodynamics, and Complex Systems, and the Ashbel Smith Regents Professor at the University of Texas, Austin. He received his Ph.D. in Chemistry from the University of Brussels. In 1977 Prigogine won the Nobel prize for Chemistry. In 1950 he won the A. Wetrems prize from the Royal Academy of Belgium. In 1947 he was appointed professor at the University of Brussels, and was named Professor Emeritus in 1987. From 1961 to 1966 Prigogine was a Special Chair at the University of Chicago's Department of Chemistry, the Enrico Fermi Institute for Nuclear Studies, and the Institute for the Study of Metals.

12. WILLIAM R. RIEDEL is a research geologist, the Curator of Geology, and Adjunct Senior Lecturer at the Scripps Institution of Oceanography. He received his Ph.D. from the University of Adelaide, in Australia, where he was born and raised. His principal area of research has been the evolution and environmental dependencies of the Radiolarians, a group of planktonic protozoans with strikingly symmetrical glassy shells. He is largely responsible for transforming Radiolaria from an under-studied group to one of the major tools used for interpreting open-ocean sediment. He established pelagic microscopic fish skeletal debris, and coined "ichthyoliths," used as instruments for determining the ages of ocean sediment. Riedel now works on utilizing personal computers for the "intelligent" handling of information, such as programs that help inexperienced workers date oceanic sediments.

13. OLIVER WOLF SACKS is consulting neurologist at Beth Abraham Hospital, Bronx, New York, and at the Little Sisters of the Poor, New York City. He is also clinical professor of Neurology at Albert Einstein College of Medicine and adjunct professor of Psychiatry at New York University Medical Center. Sacks received his medical degree from Oxford University. He is the best-selling author of *The Man Who Mistook His Wife for a Hat*. His book *Awakenings*, based on his own experiences of giving L-Dopa to postencephalitic patients, has been made into a documentary for British television, a one-act play, two dramatic readings, and the feature film with Robin Williams and Robert De Niro, which was nominated for three Academy Awards. His book *The Man who Mistook his Wife for a Hat* has inspired an opera and a stage version. Sacks is also the author of *Migraine*, *A Leg to Stand On*, and *Seeing Voices: A Journey into the World of the Deaf*.

14. GLENN T. SEABORG is a professor of Chemistry in the Graduate School of Education, and the associate director of the Lawrence Berkeley Laboratory at the University of California, Berkeley. He received his Ph.D. in Chemistry from Berkeley in 1937 and has been on its faculty since 1939. In 1961 Seaborg was appointed chairman of the Atomic Energy Commission by President Kennedy, serving until 1971. In 1951 he won the Nobel prize in Chemistry (with E.M. McMillan) for his work on the transuranium elements. Seaborg was the codiscoverer of plutonium, and during World War II he headed the group at the University of Chicago's Metallurgical Laboratory that devised the chemical extraction processes used in the production of plutonium for the Manhattan Project. He and his coworkers discovered nine more transuranium elements, and he is the only person ever to hold a patent on a chemical element. Seaborg continues to work as an active research scientist, looking for new isotopes and new "superheavy" elements. He has authored numerous books, over four hundred scientific articles, and has been awarded fifty honorary doctoral degrees.

15. J. RUDOLPH STRICKLER is the Shaw Distinguished Professor of Biological Sciences at the University of Wisconsin, and is the Senior Scientist at the university's Center for Great Lakes Studies. In 1969 Strickler received his Ph.D. in the Department of Natural Sciences from the Swiss Federal Institute of Technology (ETH) in Zurich, Switzerland. He was an assistant professor in Biological Oceanography at Johns Hopkins University, an assistant professor in Biology at Yale University, a research professor in the Department of Biological Sciences at USC, a professor of Biology at Boston University, and the director of Boston University's Marine Program at the Marine Biological Laboratory at Woods Hole. Strickler is an experienced SCUBA diver, with over 1,200 dives. He was also the Chief Scientist on twelve oceanographic cruises around the Great Barrier Reef in Australia. Strickler's films on the feeding and swimming activities of planktonic copepods have been used in TV and film productions, including the BBC's "The Living Planet" and Walt Disney Productions' "The Living Sea."

16. ROBERT KENT TRENCH is a professor at the University of California, Santa Barbara, in the Department of Biological Sciences and in the Department of Geological Sciences. He received his Ph.D. in Invertebrate Zoology from the University of California, Los Angeles. He was an assistant professor at Yale University before teaching at the University of California. From 1980 to 1983, Trench was a member of the Advisory Committee of the National Science Foundation's Division of Physiology, Cellular and Molecular Biology. Since 1984 he has been on the editorial boards of the international journals *Symbiosis*, and *Endocytobiosis and Cell Research*.

17. JURIS UPATNIEKS has been a research engineer in the Optical and Infrared Science Laboratory at ERIM (Environmental Research Institute of Michigan) since 1973. An adjunct associate professor at the Electrical and Computer Science Department of the University of Michigan, he received his M.S.E. in Electrical Engineering from the University of Michigan. His specialty is experimental optics. He is currently working on the development of compact and self-contained holographic display systems, which in the future could be used as instrument displays for cars or as sights for optical instruments or weapons. Upatnieks has developed 360-degree holographic cameras, viewers, projectors, and holographic microscopy. He is a member of the Optical Society of America, the Society of Photo-Optical Instrumentation Engineers, and a senior member of the Institute of Electrical and Electronics Engineers. Upatnieks has published over fifty technical papers and received eighteen patents for his inventions. He has also been a consultant to the General Motors Research Laboratories, Oriel Corporation of America, and the Physical Science Directorate of the U.S. Army MICOM.

18. ARTHUR T. WINFREE is a Regents Professor of Ecology and Evolutionary Biology at the University of Arizona, Tucson. He received his Ph.D. in Biology from Princeton University. He was a professor of Biological Sciences at Purdue University and an assistant professor of Theoretical Biology at the University of Chicago. His areas of specialization are circadian rhythm physiology in diverse species, wave propagation in excitable media, and the physical chemistry of pattern-formation in oscillating reactions and excitable media. In 1984 Winfree was awarded the John D. and Catherine T. MacArthur Prize, for Theoretical Biology. Winfree has been on the editorial boards of numerous science journals, and is the author of three books and over one hundred technical publications.

BIBLIOGRAPHY

Allen, Casey. "Profile: Fritz Goro." *Functional Photography*, (September/October 1987).

Bennett, Edna. "Science Photographs by an Expert." *Camera 35*, (August/September 1964).

Elson, Robert. *The World of Time Inc.: The Intimate History of a Publishing Enterprise 1941–1960,* New York: Atheneum, 1973.

Farwell, George. "*Life* Photographs the Barrier Reef." *Air Travel: Australian National Airways Magazine,* (April 1951).

Gidal, Tim. "Ein Augenzeuge Berichtet." *Der Bildjournalist*, (September 1967).

Gidal, Tim. "*Modern Photojournalism: Origin and Evolution, 1910–1933,* New York: Macmillan, 1973.

Goro, Fritz. "Where Bretons Wrest a Living from the Sea." *National Geographic,* (June 1937).

Goro, Fritz. "On Photography in Science." *Technology Review,* (June 1945).

Goro, Fritz. "F. W. Goro." *Design,* (April 1946).

Goro, Fritz. "Tradition." *Picture: American Society of Magazine Photographers Picture Annual,* (1957).

Goro, Fritz and Edna Bennett. "Science Journalism." *Photographic Applications in Science and Technology,* (Winter 1966/1967).

Goro, Fritz. "An Experiment in Fetal Surgery." *Journal of the Biological Photographic Association,* (January 1975).

Goro, Fritz. "Photomicrography and Polacolor 2." *Laboratory Management,* (March 1976).

Goro, Fritz. "Golden Oldies: Insects in Amber." *Discover,* (May 1982).

Gould, Stephen Jay. "The Stately Mansions of the Radiolaria." *Horizon,* (Spring 1976).

Hamblin, Dora Jane. *That Was the LIFE.* New York: Norton, 1977.

Lessin, Leonard. "Fritz Goro: Science Journalist with a Camera." *Photomethods,* (May 1982).

Rogers, Dorian. "Fritz Goro." *Print,* (July/August 1979).

Smith, C. Zoe. "Fritz Goro: Emigré Photojournalist." *American Journalism,* (1986).

Whelan, Richard. *Robert Capa,* New York: Ballantine Books, 1985.

Wolf, Anthony. "Fritz Goro." *Omni,* (January 1979).

ACKNOWLEDGMENTS

This book has been decades in the making. Fritz Goro discussed the details of his assignments with his son until Thomas's death in 1970, and then with his grandsons. All helped him on assignments from time to time. In 1981, a selection for a long-planned book was made. Each photograph was discussed in detail with Goro, who made numerous additions. Most of the scientific pictures that he selected are included in this book, though often a single image had to be chosen to represent what was originally part of a longer and more complex photo-essay.

In addition to scientific subjects, Goro photographed the life and culture of Australian aboriginal peoples, the Caribou Inuit, and Breton fishermen; wildlife in the Canadian Arctic and Alaska; landscapes of the Arctic, Australia, and Antarctica; the natural history of animals and plants on land and in the water; illustrations of physical and chemical processes; penetrating photo-essays on life in the Chicago slums, Mayan archaeology, treatment of mental illness, and physical handicaps, among many other themes.

This book would not have been possible without the interest and support of the Aperture Foundation. We thank our editor, Andrew Wilkes, and all the staff at Aperture for their help and hard work in making this book a reality.

Special thanks go to Dr. Nora Goreau, the family historian, for reviewing drafts, finding pictures, and checking accuracy.

This book is dedicated to the children of the world, in the hope that they may learn to use science more wisely than their predecessors by preserving the natural wonders around them.

Thomas J. Goreau, **Peter Goreau**, and **Stefan Goreau** are the grandsons of Fritz W. Goro. Raised in Jamaica, they began swimming as soon as they could walk, accompanying their father, Thomas F. Goreau, on his pioneering diving research on coral reefs. All three were educated in Jamaican schools. Thomas J. received degrees in planetary physics from Massachussetts Institute of Technology, in planetary astronomy from California Institute of Technology, and in biogeochemistry from Harvard. A former professor and researcher in the United States, Jamaica, and Brazil, and Senior Scientific Affairs Officer at the United Nations Center for Science and Technology for Development, he is now president of the Global Coral Reef Alliance, a nonprofit research and education organization focused on coral reef protection, and Scientific Advisor to the Negril Coral Reef Preservation Society in Jamaica. Peter received degrees in geology from the University of Bristol, and in geophysics from Massachussetts Institute of Technology and the Woods Hole Oceanographic Institution. A former college professor, he now works mainly on sculpture, painting, and poetry. Stefan holds degrees in zoology and fisheries from the University of Washington. He has been a researcher at Sweden's National Fisheries Institute, and plans to pursue research in aquaculture.

Aperture gratefully acknowledges a generous grant from the E.T. Harmax Foundation in support of this publication.

Library of Congress Catalog Card Number: 93-70320
ISBN: 0-89381-542-X

Cover photograph and photographs on pages 16, 17, 18, 19, 21, 24, 25, 30, 31, 32, 33, 34, 35, 36, 37, 40, 42, 43, 44, 45, 48, 49, 50, 51, 52, 53, 59, 60, 61, 66, 71, 75, 76, 81, 87, 98, 99, 100, 101, 107, 114, 115, 119, 120, 121, 122, 123, copyright *Life* magazine.

Book and jacket design by Roger Gorman.
Composition by Leah Sherman/BettyType Inc.
Printed and bound by C & C Joint Printing Company, Hong Kong.

The staff at Aperture for *On the Nature of Things: The Scientific Photography of Fritz Goro* is:
Michael E. Hoffman, Executive Director
Andrew Wilkes, Editor
Michael Sand, Managing Editor
Stevan Baron, Production Director
Sandra Greve, Production Associate
Sarah Haviland, Copy Editor
Michael Lorenzini, Eve Morgenstern, Editorial Work-Scholars

Aperture publishes a periodical, books, and portfolios of fine photography to communicate with serious photographers and creative people everywhere. A complete catalog is available upon request. Address: 20 East 23rd Street, New York, New York 10010.

First edition
10 9 8 7 6 5 4 3 2 1